THE ART OF CREATIVITY

Praise for *The Art of Creativity*

'Great food for thought and action' **David Lynch**

'In *The Art of Creativity*, Susie Pearl – a creative force of happiness – has distilled her wealth of knowledge into practical exercises to design your life and allow your creativity to explode'

Jasmine Hemsley

'If anyone can give us insight into prolific creativity, it's Susie Pearl. Inspiration has no edges or ending, and Susie reminds us of that here' **KT Tunstall**

'If people ask me what book I recommend to jumpstart creativity, I recommend *The Art of Creativity*. It's practical and full of really great ideas to get creative and rise up through the fog. There's something essential in there for everyone, and Susie's optimism and positivity is magnetic medicine for the world' **Ricki Lake**

'*The Art of Creativity* has helped me to transform my way of thinking so I could live a more intentional life. This book will take your creative flow to another level. It's magical and fun and you will never feel the same again after reading it' **Patsy Palmer**

'Think you aren't creative? Think again. Susie Pearl's genius step-by-step guide to igniting your creative spark will take you on a journey of self-connection and discovery that will bring out the inner genius in us all. Whether you think you're a creative newbie or are looking for divine inspiration for a project, this easy-to-use book will get the creative juices flowing and stir up the inner originality that lies deep within all of us. You'll also find it brings technicolour magic into all areas of your life in the process'

Susannah Taylor

'Susie Pearl helps you to understand what's blocking your creativity and offers clear techniques to help. Her calm and insightful writing can unlock everyone's true artistic potential. You might not think you need this book, but you do!' **Miranda Sawyer**

THE ART OF CREATIVITY

7 Powerful Habits To
Unlock Your Full Potential

SUSIE PEARL

First published in Great Britain in 2020 by Orion Spring
an imprint of The Orion Publishing Group Ltd
Carmelite House, 50 Victoria Embankment
London EC4Y 0DZ

An Hachette UK Company

10 9 8 7 6 5 4 3 2 1

A CIP catalogue record for this book is
available from the British Library.

ISBN (Hardback) 978 1 4091 8308 2
ISBN (eBook) 978 1 4091 8309 9

Designed by Goldust Design
Printed and bound in Great Britain by
Clays Ltd, Elcograf S.p.A.

MIX
Paper from
responsible sources
FSC® C104740

www.orionbooks.co.uk

This book is dedicated to my beautiful son, Will, who lifts me to the pinnacle of life's joys with his unbounded love and creativity.

This book is dedicated to my beautiful son, Will,
who lifts me to the pinnacle of life's joy with his
unbounded love and creativity.

CONTENTS

CONTENTS

*'Where the spirit does not work
with the hand there is no art.'*

Leonardo da Vinci

INTRODUCTION

'Consultants are now creative consultants; advertising agencies are now creative agencies. Creativity has almost become a moral imperative.'
Carrie Battan, *The New Yorker* [1]

This is a book that finds you when the time is right. When you are ready to expand your horizons, you'll find that doors will open for you. *The Art of Creativity* represents that door.

This is a book for anyone wanting to access more creativity and flow in their daily lives. Maybe you believe that you have little or no artistic talent. Perhaps in the past you have been told you lack creativity by a parent or teacher. It may be that you are someone who is naturally creative, and you want to develop better habits and even greater skills. Wherever you are on the scale of creativity, *The Art of Creativity* will take you into a deeper level of personal and creative

transformation. Along the way, you will learn the daily habits that highly creative people have cultivated, habits that will allow you to unleash your full creative potential. And you will soon see the positive impact this has on your everyday life, including your career, health and relationships.

We all have the power to be creative

According to Adobe's State of Create global benchmark study (based on 5,000 adults from the US, Europe and Japan), only one in four people believe they are living up to their own creative potential, and four in ten people believe that they do not have the tools or access to the tools to create.

The problem, as Sir Ken Robinson – bestselling author, TED speaker, education and creativity expert – explored in his 2006 talk, 'Do Schools Kill Creativity?', is that traditional educational systems are not designed to support students in developing their natural creative powers. Instead, education systems generally tend to encourage uniformity in thinking, with a focus on learning facts and standardised tests measured by simple right and wrong answers. There is little focus on creative enterprise or building emotional

intelligence. The result is that we are draining people of their creative possibilities and producing a workforce that is conditioned to prioritise conformity over creativity.

However, like Sir Ken Robinson, I believe that everyone is creative: all human beings have the power to connect to a stream of creativity and find happiness and fulfilment in the process. It doesn't matter if you want to become a writer, singer, musician, artist or designer – or indeed none of these things. Whatever you want to pursue is possible with the right positive belief systems and a step-by-step approach like the one you are about to embark on.

You already have what it takes to develop your own unique curiosity and creative instinct. The treasure lives within, and you hold the key to accessing a more creative life in your hands right now. So let's begin by demystifying the concept and define what is meant by 'creativity'.

What is creativity?

creativity (*noun*)

The use of imagination or original ideas to create something; inventiveness.

Oxford English Dictionary

People often think of creativity as making something, yet the true application of the concept goes far deeper. The word creativity is derived from the Latin word *creatus*, which means 'to have grown'.

Ultimately, creativity means different things to different people. For the purposes of this book, it includes the broadest range of artistic and mind-enhancing pursuits, from writing, drawing, painting and singing to teaching, cooking, photography, acting, designing and creative problem solving.

Close your eyes and think of the last time an exciting idea came to you or when you found a solution to a problem that had been bothering you. Remember how it felt in that moment: the adrenaline rush, the increased heart rate, the prickly feeling on the back of your neck. Perhaps you sat up straighter in your chair, smiled or clapped your hands in delight. This is what's called a 'lightbulb moment'; in other words, a moment when you accessed that deep well of creativity inside

yourself and enjoyed the rush of good feelings that arose as a result.

From that moment on, it might have felt like you were on a roll: perhaps you got a call from someone connected with the idea and experienced a sixth sense that things were lining up, that everything was falling into place and you were somehow on track. This was the beginning of the state known as being in 'flow'.

In his book *Finding Flow*, psychologist Mihály Csíkszentmihályi defines 'flow' as an 'optimal state of consciousness where we feel our best and perform our best'. More simply, 'flow' is the mental state of being totally immersed in a task. It's the place we occupy when we lose track of time and sense of the outside world. External distractions become less important. The flow space can feel like it is somehow not governed by time. But accessing the flow state is easier said than done, so this is something we will explore on this journey together.

Why is creativity important?

Art and creativity have played a central part in the development of cultures from the beginning of humanity. From the first caveman paintings to the

great pyramids of Egypt, modern art and architecture, art represents the pinnacle of human endeavour and captures the ideas that travel across countries and generations. Art unites people irrespective of race, religion, age, language or politics. It creates an energy, a shared emotional experience that connects people.

The stress of modern living – our fast-paced lifestyles, the constant stimuli and interruptions, being continually 'on' and 'connected' – can play havoc with our ability to tap into that inner creative well in a natural way. In this busy world, our free time is squeezed so tightly that we don't make time or space for our creative side to be expressed. However, we must allow some creative flow in life if we want to feel completely fulfilled and happy. Living creatively is about living life as an exciting journey and seeing simple, everyday things in unique ways.

Creativity has never been more important for the world than it is today. We live in a time in which data is generated daily in vast quantities and broadcast globally and instantly. What we need are the tools to interpret such information intuitively and creatively in order to innovate, develop and filter through the noise to focus on what is most important while ignoring the rest. Creative problem solving enables us to redefine problems as opportunities and, in doing so,

identify innovative solutions that lead to great success.

Creativity is the new global currency in twenty-first-century businesses. According to a poll of 2,040 adult US consumers conducted for *TIME* magazine, Microsoft and the Motion Picture Association of America (MPAA) in 2013, 91 per cent said that unleashing creativity is vital to our personal lives, and 83 per cent believed it's important for our professional development.[2] Of those polled, creativity came out as the most valued characteristic in others (94 per cent), ahead of intelligence (93 per cent), compassion (92 per cent), humour (89 per cent), ambition (88 per cent) and beauty (57 per cent).

It follows that, now we can create, produce and direct from our own devices from any place in the world, a creative mind is one of the most sought-after skills in the global marketplace. Employers are increasingly less interested in how long it takes people to do a job, and care more about the quality and creativity of the ideas. One of my clients, the CEO of a major film production company in LA, told me that one of the most important assets of their organisation is the creativity of their team. And yet, she continued, 'It's the hardest part of this business, to find truly creative talent.'

The workforce is rapidly changing. There are more opportunities for people to forge multi-layered careers,

and to choose to define their own roles – whether that is being an entrepreneur-blogger, a podcaster-filmmaker or a social media influencer. Therefore, creativity has become an important and valuable skill in a world in which anyone can write and publish/broadcast their work.

A recent World Economic Forum report predicted that more than five million jobs will be lost to automation and robots in the near future, with research suggesting that manufacturing, transport and public administration – especially administrative jobs – will see the largest losses. It follows, therefore, that with machines doing more of the heavy lifting, the roles that do remain will have a stronger emphasis on creative thinking.

Analysts of future trends are predicting that the classic working week will be defunct soon and that we will be living longer and working less.[3] We'll have time for creative habits and to explore our inner artist. This book will help you get on this journey – fast – and fully connect to the artist within so that you are able to claim your creative birthright.

What will you gain from this journey?

Powering up your creative life is a healing process on both an emotional and energetic level, and engenders a powerful personal transformation in unexpected ways. One of the most beautiful aspects about the journey you are about to embark on is that you can't get it wrong. There might be exercises or tools in this book that don't resonate with you, and that is fine. The most important thing is that you have chosen to walk on a more creative path – and in doing so, you will develop a deeper wisdom and connection with who you truly are.

When we dig deep and access that well of creativity inside ourselves, the effect is about more than just increasing our artistic output. Our relationship to ourselves shifts into a space of greater awareness, and in turn we build more compassionate relationships with others. Making time for art and creativity is also self-care: remember, you are doing yourself a favour when you make time for art and craft in your life.

By working through each of the chapters in this book, you will gain three benefits. First, you will feel a stronger connection between your heart, mind and body. When the heart and mind are in sync, a deeper, more intuitive process opens up. Creative writing is used in prisons, for example, to help prisoners

remember who they are 'beyond the crime' that they have been found guilty of. It gives inmates an opportunity to explore feelings that may have been pushed away and ignored for a long time, and I have heard prisoners talk about the immense sense of relief they get from being able to write their own stories and shape their own narratives. It is all part of a healing journey towards rehabilitation.

Second, this book will unblock deep fears and obstacles, not just around creativity, but in any area where you may be experiencing feelings of being stuck, lost or blocked. When you get into the creative flow, there is a positive impact in other aspects of your life as your belief systems and paradigms shift. You will find greater flexibility of thinking, and this will give you fresh perspectives and help you solve problems at a higher level than you have done before.

Third, by unlocking your creativity, you will find happiness and fulfilment. When we break through limiting beliefs, we access a place where we can experience deeper joy and a greater sense of inner harmony. Building creativity is a life-changing process. Expect to see a shift in your relationships, your health, your career and your sense of adventure, as well as a greater serendipity all round.

Life will move forward as you work through the

stages in this book. Ideas will spark and your unique personal creativity will flower. Things will not stay the same – that is for sure.

My creative journey

Just like many other people, when I was young I was under the impression that I had little creative talent and wasn't very good at art, singing or writing. My English teacher covered my creative writing exercise books with fierce-looking red lines, crossing out words, correcting my style and adding critical comments that were discouraging to read, especially at that tender young age, and it remains a strong negative trigger all these years later. I don't remember the negative comments being balanced by any good things she noticed. I also received low marks consistently in all my creative lessons. Back then I didn't dare to dream that I would become a published writer, and yet, here I am doing what I love.

During my early working life, I had over fifteen jobs that were all very different, and each one of these contributed to the skills that I use in my work today. My first summer job as a teenager was spent in the art therapy department of a rehabilitation unit at a local

hospital. We used art as a tool to help people recover from severe mental and physical illnesses.

It was here that I saw for the first time the power of creativity to heal and restore the human spirit. Painting, storytelling, poetry and art brought these people together in a community and gave them a chance to reconnect with their hearts, with their souls and with one other. The healing that the patients experienced through the creative therapy sessions was evident for all to see, and for many patients it became their favourite part of the week.

Later, I worked in the creative industries, including producing TV shows and creating international events for MTV. I founded an entertainment PR agency in London and ran large-scale events that took me to all corners of the globe and allowed me to get creative with big budgets to produce ideas and publicity for mind-blowing music and entertainment shows, such as the MTV European Music Awards, the MTV Video Music Awards in New York and Madonna's world tours. These were all culminations of high levels of creativity in design, performance, artistic rendition and fashion, and meant that I got to work with the most talented creatives in the field.

In later years, I was asked by Paul McKenna, one of the UK's most successful self-help authors, to become managing director of his personal transformation

company. I was in charge of running the neuro-linguistic programming (NLP) personal development seminars hosted by him and Dr Richard Bandler, the creator of NLP. I worked with both of these highly creative people for over seven years, producing workshops, events and programmes and managing the teaching of advanced mental techniques for creating fast and powerful personal transformation.

In these seminars, I saw how people who were self-confessed non-musicians and non-artists could get up on stage after a couple of hours of hypnosis and NLP and perform incredible musical sets, jamming with instruments they had just picked up for the first time. Others painted extraordinary artworks that sold later to members of the audience. The art produced by these previous 'non-artists' was very impressive indeed.

Witnessing these experiences exploded my long-held belief that creativity is something we are born with, and we either have it or we don't. I now know that we can be taught to develop the skills of creativity, and that it can be accessed by anyone given the right mind training. I have worked as a mentor and creative coach for companies such as MTV, the Huffington Post, Google and Sony, helping people to tap into their creative stream and find success in the process. Now it's your turn, so let's get started.

EXERCISE:
JOURNALING

While you journey through this book, you are going to encounter some practical exercises. It's important to actually *do* these tasks, rather than just read about them. Undertaking the exercises will hardwire your mind to approach things differently and capture the essence of your own creative flow.

Choose a journal that you love; it doesn't matter if it has lined or blank pages. It's going to hold some of your most precious thoughts, desires and dreams, so make sure it's beautiful and worthy of this. Your journal is not meant for sharing with others – it is private, unedited and only for you to read.

When you see the following symbol ⋊ it means that you'll need to use your journal, so keep it close to hand, ready to make notes in.

Journaling is an important part of the process, and we cover this in more detail in Habit 2: Journaling (see page 49). In the meantime, complete the following sentences in your journal:

1. I am committing to go on this road of unlocking my creativity because . . .

2. What I want to get out of this book is . . .

3. My intention in reading this book is . . .

4. The obstacles I expect to encounter are . . .

Habit 1

FEARS AND BLOCKS AND HOW TO OVERCOME THEM

'You gain strength, courage and confidence by every experience in which you really stop to look fear in the face. You are able to say to yourself, "I have lived through this. I can take the next thing that comes along." You must do the thing you think you cannot do.'
Eleanor Roosevelt

We all know people who are constantly fearful and worry about what may or may not happen, and it is easy to slide into such negative patterns of behaviour without even noticing. It's also an infectious habit – if someone around you is constantly worrying or talking negatively, it's easy to find yourself mirroring that behaviour. Yet most of the time the thing we worry about never actually happens.

This chapter is about helping you to escape such

negative loops, to stop overthinking and letting fear hold you back, and to instead adopt a more positive mindset and can-do approach. You will soon notice that this one simple shift will change your life for the better, fast.

Through my work as a creative coach, I have noticed that one of the common habits of highly creative people is their ability to acknowledge their fears and to work on them to reduce their impact. Once we recognise and name our fears, we have every chance to deal with them positively, turn the fear around and use it for transformation and personal growth.

Humans are born with two innate fears: a fear of falling and a fear of loud noises, both of which we are hardwired in us from birth. As we grow older, we develop other fears through our upbringing, culture and the external influences of parents and peers. Often, fears are created by events or situations that imprint upon our consciousness and, when repeated, create an emotional response that makes us feel scared or afraid. These fears might be tangible things you can see, touch, smell and experience. For example, you may have a fear of heights, flying, enclosed spaces, open spaces, success, failure, unfamiliar social situations or spiders, or it may be other things that create a fear trigger for you. Everyone has different associations around fear.

Fear is a natural built-in response to help us stay safe and avoid potential dangers, and we react in one of three ways: fight, flight or freeze. It's an ancient mechanism designed to keep us safe in our environment. For most of history, humans were exposed to threats from the surrounding environment, but in modern times these threats have shifted largely from external to internal triggers. For example, unless you live in the wilds of Africa, you're probably not at risk of being mauled by an angry lion. But you might worry about what people think of you, about not having enough time, talent, ideas, education, opportunities or freedom to achieve a task or goal. To put it simply, you're probably worried about failing or being hurt – and in this way, fear can hold us back and be hugely debilitating, standing in the way of you reaching your full potential. Because of this, it is really important to keep fears in balance.

To make our fears even more tricky to deal with, we often don't know what they relate to on a conscious level. They lurk beneath our awareness, buried deeply by the ego, which serves to protect us in the best way it can. Through childhood and our formative years, we might pick up assumptions and adopt negative beliefs about ourselves from teachers, parents, siblings and friends. You might have been told that you are not

artistic, that you're tone deaf, have a terrible singing voice or – like me – told by a teacher that creative writing isn't your strength. You might not have minded at the time, but you may have buried that belief deep within yourself, hardly noticing what you were doing, and this could be holding you back without you even realising.

So how can we address what we don't know or understand? Those who are successfully creative have learnt how to work through their inner blocks and come out the other side. This chapter will give you the tools to do the same, and completing these exercises will heal you energetically and spiritually.

The first step in breaking through your blocks is to remember that *you are not your fears*, in the same way that *you are not your thoughts*. We experience fear in the same way we experience other thoughts and emotions. We are housed in our bodies, constantly reacting to the feelings and ideas we allow to run through our minds. We are the observer of our own inner and outer worlds and the ultimate analyst and decoder of what we observe. We decide where we focus our attention, and this means we often choose to ignore feelings that make us uncomfortable or cause pain. In order to access our true creative potential, we must face up to what's on the inside.

After all, if we can't bring ourselves to notice and acknowledge the obstacles, how can we hope to overcome them?

When you face your fears head on, they will dissolve. This is the only way to clear and release what is holding you back. This may be an uncomfortable process, and that's okay. Know that this is part of the journey. Remember to enjoy any feelings of discomfort, safe in the knowledge that this is a healing process.

Now, let's get started.

EXERCISE:
GET UP CLOSE WITH YOUR FEAR

Get your journal and a pen and head to a quiet place where you won't be disturbed. Put your phone out of the way and activate silent mode.

Take a few minutes to sit down, close your eyes and pay attention to your breathing – inhale and exhale with conscious awareness. Check in with yourself and get a sense of how you are feeling, paying attention to your body and emotions.

Now, allow yourself to feel all your fears. One way to do this is to think of something that you know scares you. Run it like a movie in your mind's eye and tune into the feelings you experience when you think about it. Make it as visual and real in your mind as you can.

Notice the emotions that arise and name them; pay attention to how they feel and try to locate where that feeling arises in your body. Put your hand on that area of your body. For example, it may be your chest, your stomach or your legs – your body will let you know where it is.

Breathe into that area, acknowledge the feeling and ask yourself to allow that tension to release – and so releasing the energy block in that area of the body. I find it effective to frame this as a command – the body loves being told what to do by the mind.

When you feel ready – and take your time with this process; there is no need to hurry – open your eyes and write the answers to the following questions in your journal:

1. What am I afraid of exactly?

2. What is the worst thing that could happen in this situation?

3. Who do I avoid and why? How do these people make me feel, and why?

4. What has been stopping me from starting my next creative project? (List everything that comes to mind, including any feelings and emotions around these blocks.)

5. Who is my biggest critic?

6. What is the tone of voice I use for my inner self-talk?

7. What stops me being creative? (Note any insights into when or how you picked up these blocks, for example in childhood or at school, from parents or peers.)

8. How will I know when I am creatively unblocked? What will I be able to do that I can't do now?

Fight the fear!

For each negative belief or fear you hold, write down a positive affirmation to counter it. By doing this you will bust the negativity habit and instead adopt a more positive way of looking at the world.

Affirmations are more powerful than you may believe, and they really do work on a level that is hard for us to comprehend. I have seen the results speak for themselves time and time again with my clients. They have a powerful effect in dismantling old negative belief systems in your subconscious.

You cannot argue with your subconscious mind if it believes you deserve more time and space to do the things you love. Tell it you are worthy of this and do so regularly. Try it out for yourself and trust this process.

Here are some examples to help you:

I haven't got the talent to be a real artist.

I am grateful for the creative gifts I know I have, and I am learning to appreciate and expand my inner talents through regular practice and by showing up to learn more. I understand that creative skills can be developed and know that I am on the road to developing my natural skills now.

I can't sing very well.

I'm grateful for the desire to sing and know that I can practise and get help enhancing my voice. I appreciate listening to good singers and know that I will find my own voice. I'm looking forward to practising vocal exercises to increase my range.

I don't have enough space to do what I want to do.

I am happy to choose a place in my living space that is dedicated to my creative projects. I am free here to do what I want, how I want. I am choosing to find groups locally that I can join to get the materials and advice I need to start deepening my creative quest. I'm proud of my motivation to find my creative self.

I don't have the knowledge or skills to play an instrument.

I am feeling musical and motivated to learn a new instrument. I will seek out a local group or teacher to help me learn. I'm already feeling the joy and empowerment of learning a new instrument.

I'm busy and don't have the time to be creative. I have a family, kids, house chores that stack up and an exhausting job that takes up all my time.

I am grateful for finding time for myself to explore new things. I find it easy to give twenty minutes a day to myself, knowing that I am a step closer to

achieving my dreams. I can find the time to relax and play. I deserve this in my life. I block out time in my diary because it makes me happy.

Try practising your affirmations daily or even twice a day, ideally first thing in the morning and before you go to bed. Write them down and repeat them out loud to yourself. Use sticky notes to put them up on the wall and leave them where you will see them. Keep changing them and modifying them to keep them fresh.

How to overcome blocks

By getting up close to your fears in the previous exercise, you will now have a better understanding of the blocks that have been holding you back from leading a truly creative life. We need to be clever to navigate the many excuses we come up with – lack of time, resources, energy, lack of mental space – that stop us making time for creativity. In the next section, we will address the most common obstacles that people put in the way of their creative path, so that we can hurdle over them once and for all.

Block 1: I don't have time to be creative

When I meet someone new and tell them that I'm a writer, they often say they have always wanted to write a book. And then usually what follows is a reason why they haven't done it yet – either they haven't got around to it, they've not had the time to give it their full focus or they feel they aren't ready.

They comfort themselves by saying that they will get around to it one day. Yet we all know that, ordinarily, a clear and uninterrupted stretch of time is unlikely to come along unless we actively take

steps to make it happen. We're constantly working, answering emails, shopping for food, looking after our families, meeting new people, responding to other people's demands for our time and getting lost in social media – all distractions that make us forget our good intentions. So there will never be a perfect time to start your book or whatever your creative endeavour might be. And excuses won't cut it if you want to get the results. You have to be honest about what you really want. How you spend your time day by day is a choice – one that you are in charge of.

It's always possible to make adjustments and create space – even just finding an hour here and there. To get past such distractions requires some deliberate effort, focus and dedication. The fact that you are reading this book now is a brilliant first step.

Many successful writers and artists began doing their work by snatching time in between other parts of their busy life. J.K. Rowling famously worked in a café and managed to draft the early chapters of *Harry Potter* as a single mum with a young baby sleeping by her side, with little money, surviving on welfare benefits.

It is possible to squeeze in time between being a parent or having a career or a full-time job. First of all, notice how you spend your time each day. Take a good look at your routines and habits, and see if they are

serving you in the best way. Are you using your time well? Could you use it better? Is there enough exercise, fun, socialising and learning in your life? Are you doing many things that you really don't want to do or that are not serving your best interests?

Assess your use of an average day honestly and realistically. Time is the most valuable commodity we have – we cannot get it back, so spend it wisely.

Ten ways to make more time in your life

1 **Put some 'you time' in the diary:** Block out some time in your calendar, once a week, that you keep precious and free just for you. Fill this time with something artistic and give yourself full permission to have fun.

2 **Food preparation:** Make repetitive jobs efficient – shop for food once a week. Plan meals ahead and freeze some to save time each day. Batch cook using a slow-cooker. Getting organised in the kitchen will save you hours every week.

3 **Automate your bills:** Put your regular bills on direct debit to save time on admin. Get all your banking automated via apps so you can handle your finances without needing to visit your bank.

4 **Set boundaries:** Say 'no' to more things to free up your diary. You don't have to go to everything you are invited to. Carefully curate what you do, who you see and when. Remember how valuable your time is, so make good choices about how you spend it and with whom.

5 **Simplify admin:** Put all your paperwork requiring action into a file and look at it once a week or monthly. Anything urgent, just mark in your diary a day to deal with it and then forget about it until that day arrives, then deal with it swiftly. Ideally, handle each piece of admin only twice – once to put it into the file and then a second time to action it.

6 **De-clutter your inbox:** Deal with your emails at certain times of the day. Read them, then either delete them, file them or reply straight away. Action them and move on, fast. Empty your inbox – it feels great to do this. You don't need to hang on to old messages most of the time – it just slows you down and creates distraction.

7 **Remove unwanted distractions:** Delete your name from unnecessary mailing lists and newsletters. Delete apps that are distracting you. I have unsubscribed myself from most mailing lists and that single action has given me a lot of time back. I'm not bombarded by incoming information and I get to decide what I want to read about and when.

8 **Plan ahead:** Write a to-do list before you go to bed so that the next day you know what your priorities are without needing to think about it. Aim to have a maximum of five to ten items at any one time on your to-do list and schedule the rest in your digital calendar. If you record it in your calendar and give it a time and day slot, you know you will get around to it and can forget about it in the meantime. As a friend once told me, a good day starts the night before with a plan for tomorrow.

9 **Minimise your stuff:** Too much stuff around you slows you down. Take a weekend and do an edit of your home and work space, throwing out anything you don't need or rarely use. You will find yourself energised and better able to get things done when you are not weighed down with too much stuff.

10 Rest: Get plenty of sleep and go to bed early. If you are well rested, you will feel energised and more creative. Follow the natural rhythms of the day – when it gets dark it's time to slow down, and as the sun rises it's time to wake and start the day. Being well rested helps to sustain positive emotions and keep yourself in a great mood – essential for your best creative endeavours.

Block 2: I don't want to embarrass myself

In his book *The Art of Learning*, Josh Waitzkin talks about investing in failure. He explains that while he was training in tai chi, he noticed that most people chose to train with a partner at the same level or slightly below their level so that they would win.

Instead, he recommends the opposite approach – choose a partner who is better than you and who will pull you up to their higher standards. You may get kicked and thrown over, but you will quickly learn and improve by mirroring your opponent's skills. Sometimes, it makes more sense to fail so that you learn the lessons you need to succeed in the long term.

In the same way, on your journey to your most creative self, seek out those who seem more talented

than you and who you admire so that you can improve, learn and build up your own creative muscles. Watch and learn. Rather than feel the need to be the smartest person in the room, make it okay to be the dumbest person in the room and get out of your comfort zone. When we drop the need to 'be right' or 'the best', we can more easily develop a beginner's mindset, which gives us the opportunity to expand, learn and improve. It's in this space that you will discover the best lessons for personal growth.

At the same time, swerve toxic friends and those who are always critical of you. We all know people who bring us down and make us feel bad. We have a choice about who we spend time with, so choose carefully. There is no point in surrounding yourself with people who sap your energy or make you question your talents as a creator. We don't need that kind of negativity around us.

Those who have yet to acknowledge and overcome their own mental blocks are often the first to cast doubt because of their own insecurities around their creative

output. Don't let others bring you down. When people are fast to critique your work, it says more about them than it does about you. Some people find the success of others threatening, so remember to filter out negative feedback that you don't agree with and don't take it on as your own truth. It's good to listen to constructive criticism, but if it's holding you back, notice that and move on quickly. Be your own barometer of what you produce – if you think it's good, then it probably is.

Block 3: I don't like being outside my comfort zone

As well as surrounding yourself with more talented people, actively seek opportunities to push yourself out of your comfort zone.

In order to reduce phobias, such as a fear of spiders, some therapies involve a gradual exposure to the subject of the fear. This is a process called habituation and works by desensitising an individual's response to a fear trigger through time and contact.

With this in mind, it is important that you keep showing up in the space outside your creative comfort zone. Join a new class; it could be pottery, art, music, singing, acting, calligraphy – it doesn't matter what it is. It also doesn't matter how you get on and whether you are any good at it. It's the undertaking that counts. Drop the need to produce something that is perfect or wonderful. Making mistakes and not knowing is a great resource for boosting creativity, experimentation and learning.

Get messy, get dirty and play like you just don't care. The mix of uncertainty and pleasure is a delicious combination for creating.

Block 4: I can't do it

How we talk to ourselves from the inside determines how happy we are and how secure we become. If you tell yourself you aren't creative, successful or happy, you will feel uncreative, unsuccessful and unhappy. When we pay attention to how we talk to ourselves and work to improve the content and tonality of our self-talk, life shifts toward the positive, and we can overcome our fears and blocks.

Neuro-linguistic programming (NLP) training has great techniques for increasing awareness of what's going on inside and improving your inner dialogue. When I first began mind training with Dr Richard Bandler, co-creator of NLP, I started to become more aware of the internal soundtrack I was playing in my head, and I was amazed at what I learnt from my observations. I realised I told myself things that I would never think or dare to say out loud to anyone else – things that were rude and nasty and said in a tone that wasn't kind or supportive but often downright mean.

When we clean up our inner dialogue and become more aware of it, the relationship we have with ourselves and the world around us changes as if by magic. We shift our feelings, and by doing so we alter our destiny. Try it just for one day and see what happens.

EXERCISE: TACKLING NEGATIVE SELF-TALK

We have a soundtrack playing in our minds almost constantly. We chat to ourselves with a running commentary on how we are feeling, what we are thinking, what we are planning to do next, our reaction to events happening around us and so on. It's always there; we rarely stop to think about it or notice the impact it is having on our lives. Now it's time to observe and take notice of that inner voice.

How do you talk to yourself? Are you kind and encouraging or critical and harsh? Let's find out.

Get your journal, sit in a quiet place and spend time listening to yourself. Write down *what* you say to yourself and *how* you say it. Is the voice gentle, encouraging and soft, or harsh and critical? Write some words about your inner voice and describe it as much as you can – include notes about the content of the self-talk, the tonality and volume; notice if it is generally positive or negative.

You can make changes to the soundtrack in your head simply by bringing your awareness to it. Play with it. Make your inner voice soft, attractive, encouraging and supportive. Make it sound gentle with an appealing tone.

See what happens when you make up some rules for yourself and banish personal criticism from your self-talk. For example, if you find yourself saying negative statements to yourself like, 'I am stupid. I have never had any luck as a writer – who do I think I am to call myself a writer?', notice it and change it to positive words, starting with some opposing affirmations.

These might be:

★ I am entitled to allow my creativity to flow – it's a birthright.

★ I have creative talent and plan time for it in my life.

★ I enjoy being around other creative people and actively seek them out.

★ I am proud of my talent and skills, and love improving myself.

★ I love experimenting with colours and words.

★ I am willing to try out my creative talents without needing the outcome to be perfect.

★ I am not afraid to fail. I am fine about making mistakes.

★ I am a powerful creator.

★ Creativity is a natural expression of myself as a human being and is available to everyone.

★ I choose to release the fears and blocks that have been holding me back on my creative path.

Write a list of your own positive affirmations, ones that work for you and that you feel naturally drawn to. Review them each morning, keep adding to them and make time each week (ideally before you begin your working day) to say them out loud.

Your brain will absorb the affirmations as though they are instructions and will create circumstances to support your positive statements and make them true.

Take note of the coincidences that start to stack up once you begin this process and note them in your journal. This will help to maintain the positive cycle of affirmation–confirmation, and will embed this as a habit you maintain for the long term.

MY POSITIVE AFFIRMATIONS...

Block 5: I don't have the energy

It's easy to tell ourselves that we don't have the physical energy to be creative. Perhaps you aren't getting enough sleep, or you've been working long days at work and feel exhausted. It may be that you have kids and a family that take up a huge amount of your time and energy. However, we must remember that creativity gives us energy.

Tapping into your creative well is an extremely invigorating process. Once you are in the flow, time flies and you can unearth a source of energy that you might not have known was there.

To help myself get into the right frame of mind, I often go for a walk in nature. I have some of my best ideas when I am outdoors – inspiration strikes in a way that would never have happened if I had stayed stuck at my writing desk. Indeed, it is scientifically proven that children and adults learn better when they are outside in green spaces. *The Journal of Environmental Psychology* states that spending twenty minutes a day outside is often all you need to reset your brain, restore peace and start functioning at a higher level of performance.[1] If you are a city dweller, head to a local park. Get outside and get inspired: breathe in the fresh air, listen to the birdsong and notice the colours and

what is growing around you. This is when we can open up to flow, helping our unconscious to grasp the ideas that have been floating just out of reach.

Block 6: I don't believe in myself

I called myself a writer many years before I had written anything of significance. It was a sense, a hunch I had that this was my calling. However, I had no evidence or experience to back it up. I would tell people at parties, 'I am a writer,' and it felt good to say it because it resonated with how I felt within myself.

It was when I started working with Paul McKenna that I got the chance to really test out and demonstrate my skills as a writer. I was given the opportunity to contribute and draft ideas for some of the chapters of his self-help books. In doing so, I found that the mystery of the writing process melted away. I had put writing books high up on a pedestal and when I just started doing it, without any fear attached to the process, I realised that I could actually write – it was no longer some mystical, unreachable milestone in my mind. It was only by being thrown into the deep end that I was able to accept that I was indeed a writer. I needed my own proof to dismantle my belief system that it was

'hard to write a book' and then get published.

After that experience, I continued to write at home, working on my own book, and before long I had a complete manuscript ready to send to an agent for a review. From there, I soon got a book deal and became a published author under my own name with my first book, *Instructions for Happiness and Success*.

I am living proof that when we bust our beliefs about what is possible by actually jumping in and doing the work, our minds open up to new possibilities. It's not always easy to get your creative output recognised by peers and agents, but unless you make a start somewhere, the art will never get done. My advice is just to start and see what unfolds.

One of my favourite books, and one that I regularly gift to friends, is called *Simple Abundance: A Daybook of Comfort & Joy* by Sarah Ban Breathnach. It contains 365 essays, one for every day of the year, to help the reader see how daily life can become an expression of your authentic self. The book has a wonderful mystical alchemy where spiritual practice is supported with practical ideas, and it is a celebration of living a simple and plentiful life.

At the start of her book Sarah writes that finding a publisher was a demoralising process. She was turned down thirty-two times over a period of two years.

Her agent would break the news to her slowly, through a few painful letters at a time. The reasons given to her for passing on the book were many – some publishers said it wasn't commercial, others that the audience would be limited. But she couldn't forget the urge she had to get published. She felt it was her mission and she kept going. Ten years and 7 million copies later, her book has now been translated into over thirty languages.

I love a success-against-all-odds story and there are so many other examples of this in history. Albert Einstein wasn't able to speak until he was almost four years old and his teachers reported that he would never amount to much. When Michael Jordan was dropped from his high-school basketball team and went home, he locked himself in his room and cried because he felt like a failure. Walt Disney was fired from a newspaper job because he was found to be lacking imagination and original ideas. Steve Jobs was fired at thirty years old from a company he had founded and he left feeling devastated and depressed. Oprah Winfrey lost her job as a TV news anchorwoman and was told that she wasn't fit for television. The Beatles were rejected by the A&R team at Decca Records because the management team didn't like their sound – and the record company wrote a letter to the band to say that,

as far as they could see, they had no future in the music business.

There are endless stories and examples like these of great talent being put down, rejected and discouraged on their creative journey. It's almost as if some roadblocks are needed to increase motivation, grit and tenacity and help drive you forward. The point is simply this: don't believe what others tell you and don't take on other people's views and fears – they do not belong in your world. Create your own storylines based on your own belief systems. If you want to succeed in your area, you can. If you want to write a book, you can. If you want to make music, you can. If you want to make art, you can.

Make it a daily habit to go forward with courage, recognising your personal fears and blocks as simply moveable pieces. Only you have the power to know what journey you are on and where you are meant to be going. Keep looking forward and take it one step at a time.

Habit 2

JOURNALING

'I can shake off everything as I write; my sorrows disappear, my courage is reborn.'
Anne Frank

Life is busy and sometimes it's hard to successfully identify the priorities on our long to-do lists. We are constantly bombarded with ideas and thoughts; studies suggest that the mind processes between 60,000 and 80,000 thoughts a day – that is an average of 2,500 to 3,000 thoughts an hour.[1] Yet we don't remember or process a lot of this information in a meaningful way. That's where journaling comes in.

Journaling – the act of writing down your thoughts and what happens day by day – helps you to translate your thoughts on the page, thereby creating more headspace. It is one of the most powerful habitual activities we can adopt, helping to free us of 'mental clutter' and bringing more awareness to our thought patterns.

As we explored in the previous chapter, the quality and content of our inner monologue affects our happiness and wellbeing. Journaling enables us to objectively review our thinking and to monitor the tenor of our self-talk. In his book *Redirect: Changing the Stories We Live By*, Dr Timothy D. Wilson says that writing interventions can really nudge people from a self-defeating way of thinking into a more optimistic cycle that reinforces itself. He adds that the act of writing forces people to look at what is troubling them and allows them to find new meaning in it.

Journaling also helps the brain to process events, desires and wishes, and brings awareness to thoughts that may be buried deep inside. Allowing words and ideas to flow naturally from your brain to the page, without editing, helps the unconscious mind to swim to the surface and become seen and heard. This may unearth deep fears and insecurities that you can now confront with the tools you'll learn in this book (see Habit 1: Fears and Blocks and How to Overcome Them, page 17).

Writing for the US National Library of Medicine, neurologist Judy Willis explains that journaling can be used to train our attention and strengthen important neural pathways.[2] She describes how the practice of writing helps to enhance the way the brain absorbs,

processes and retrieves information. It promotes the brain's attentive focus, boosts long-term memory, illuminates patterns, gives us time for reflection and helps to stimulate our highest cognitive faculties.

Therapists have found that journaling is a valuable tool for examining experiences, assessing actions and coming up with insights and plans for the future. In my own work with coaching clients, I have found that CEOs and business owners use regular writing practice to help them clarify their thinking and create better frameworks for ideas, aiding them to identify the important information from the unimportant. They are able to get clearer insights from the deluge of information that they are asked to absorb on a daily basis.

So now it's your turn to try.

EXERCISE: START YOUR DAILY JOURNALING PRACTICE

As you work through this book, record your feelings, thoughts and insights directly in your journal. Anything can go into these entries: thoughts, emotions, what happened today, things people said to you that caused a strong reaction, conversations you've had. Things that made you happy or sad. Good questions to think about are: Was it a good day? What did I learn today? What do I want to do differently tomorrow? What am I grateful for?

Write about your experiences with honesty and frankness. Notice any resistance. Notice and celebrate the breakthroughs. Make your notes detailed and full of emotion. There is no right or wrong way to journal, so don't worry about making it sound good – that's not what this is about. The point of doing it is to let yourself roll onto the pages naked and real, with your absolute truth.

Writing by hand, work through the following exercises:

1. Set five clear intentions for what you want to get from journaling.

2. What activity do you want to do that you haven't got around to yet? Be specific. For example, 'write a story', 'start painting', 'begin a blog'.

3. What issue(s) might you face when doing this activity (for example a fear of getting started, a partner who seems to criticise what you do creatively, no private space to work in)?

4. List five obstacles that might get in your way, such as 'I don't have enough time', 'I'm afraid that others might read it'. Then write down solutions to each one.

5. Record your creative successes as they happen – write each of them down, whether perceived as 'big' or 'small' successes. For example, these may be: 'I wrote a poem', 'I thought of a new blog feature idea to write about', 'I collected images for my new project' or 'I meditated every day for five days'.

Make notes about transformations that you have noticed within yourself. For example, 'I read for thirty minutes each night before going to bed', 'I felt calmer when writing', 'I am becoming more open to noting down my ideas'.

If you don't know where to start, simply imagine you are having a chat with a friend and write as you would speak to that person. Let your pen do the talking.

It doesn't matter where you start, as long as you make that start.

Personal story editing

Researchers at Duke University, North Carolina, found that by writing and then editing the stories we tell ourselves and others, we fundamentally change our perception of life. This is a technique called 'personal story editing'.

The study centred on first-year students who were struggling academically. They were worried that they were not smart enough to make the grade and to continue into the next academic year.

The students were divided into groups – one was given an intervention activity and the other was studied as a control group. Students in the intervention group were asked to watch videos of other students talking about how their grades improved as they adjusted to college life. Then they were asked to write down their thoughts in a journal and were encouraged to edit and change their personal narratives about college.

The control group did not watch the videos or write down their personal story narratives.

The students who had been prompted to change their stories improved their grades and were significantly less likely to drop out of college than those in the control group. In the control group, it was found that around 20 per cent of the students

dropped out, compared to just 5 per cent from the intervention group.[3]

This study proves that through journaling we can review and then improve the story we are telling about ourselves, and by doing so affect the outcome of our own success.

Other benefits of journaling include:

Increased intelligence

A report by the University of Victoria showed a significant connection between regular writing practice and an increase in intelligence scores.[4] Journaling requires you to extend your thinking to find the words to capture what you want to say, and this helps to build new neural connections and vocabulary, making you a better and more agile thinker.

Access to mindfulness states

In encouraging the mind to have a new focus, away from stress and worry, journaling can induce a feeling that is similar to a state of mindfulness. When journaling, we start to think more widely, and in the act of writing down ideas the mind enters a more relaxed state. I prefer to call this 'mindlessness' because we are emptying our minds onto the page, rather than adding more clutter.

The act of handwriting is in itself a neuro-sensory experience. Consider what pen you write with; notice the weight of it and the way it travels over the page as you write. Pay attention to the texture of the paper you are using. Enjoy forming the shapes and letters of the words. Practise calligraphy if you so wish.

I write my journal entries every morning with a fountain ink pen, and I change the colour of the ink from time to time to keep myself engaged and feeling fresh about the process.

3 Achieving goals

When you journal, the mind can better connect with your desires and goals, bringing them into conscious awareness. This in turn will help you to manifest them, as it did for one woman who came to one of my workshops.

She wanted to write a book and start a blog but lacked inspiration about how to start either. At the end of the workshop, after listening to the benefits of journaling, she felt inspired to start writing daily.

After a month or so, she had the idea to start editing her journal entries into blog posts about parenting advice for new mothers. Now she is one of the top bloggers in her field and earns a good income from blogging while fitting it in with her family life.

The regular writing practice gave her a new spark of confidence and a fresh burst of creative energy.

Detailed goals provide a statement of intent for your mind. Without a clear road map of where we want to go, we have no hope of reaching that place. Life needs you to know your direction, and journaling will help you get there.

4 Improved memory and understanding

When you write down notes in your journal by hand, you develop a stronger understanding and deeper memory of those words, as opposed to typing them out, for example. Writing by hand takes longer, slowing the thinking process down to enable you to form a deeper understanding of the words you write. Seeing the shape of the words on the page also provides visual cues that enable better memory recall.

5 Better self-discipline

Sitting down every day to write in your journal requires real effort and self-discipline. As you start to see improvements in your life and get enjoyment from this practice, you will feel encouraged to do it more, and this, in turn, will power up discipline in other areas of your life – whether that's nutrition, exercise or other wellbeing practices.

6 Improved communication skills

According to a Stanford University report, writing has critical and positive connections to speaking fluently.[5] The more we write, the more we practice our vocabulary and putting ideas together in new ways.

As you improve one aspect of communication, other areas will naturally improve, too. Through journaling, you will be able to communicate more clearly in the world at large.

7 Personal healing

The process of writing is deeply healing – emotionally, physically and psychologically. James Pennebaker, author of *Writing to Heal: A Guided Journal for Recovering from Trauma and Emotional Upheaval*, noticed improved immune function in subjects who took part in writing exercises. Pennebaker explains that when we translate an experience into language, we make the experience graspable and more understandable. In this way, we start to heal inner wounds.

I found this to be true when working as an art therapist in the psychiatric unit of a local hospital. I encouraged patients to write regularly, without judging their output. The patients reported feeling much

better after these writing sessions; it gave them a new outlet for expression beyond talking and offered a strong sense of relief to those in emotional pain. Many even reported feeling much better as soon as they were handed a blank piece of paper – they felt free to write whatever they wanted, without being critically assessed by anyone. There is a freedom in writing for yourself.

8 Resolve writer's block

Journaling is a great way to unlock writer's block. It is liberating to know that it doesn't matter what you are writing as this is a private exercise that no one else will read.

Taking expectation or a need for success out of the mix releases the floodgates of expression and enables the words to flow.

EXERCISE: MORNING FOCUS

When you wake up, write a list of what you'd like to get done that day. This is more than a general to-do list; think of bigger things like your health, goals at work, managing your time, your social life. It's a great time to set your intentions for the day ahead, so make the list manageable and not too long.

Doing this simple exercise will create a positive shift in your emotional state. It will clarify what your priorities are and help you get the things done that are important to you.

EXERCISE: EVENING REFLECTION

The end of the day is the best time to review your experiences and notice what went well, the successes and apparent failures.

Observe what lessons and inspirations you want to take forward into the next day and notice what to remove from your routine. Think about what brought you joy today. What did you learn? What went well and why? What didn't go so well and why? What improvements and adjustments can be made to make the day better?

A good way to start the day

Josh Waitzkin, author of *The Art of Learning*, starts journaling for thirty minutes as soon as he wakes up. This way he makes sure that he doesn't get distracted by his newsfeed, emails or other people's agendas. Instead, he is starting the day with his own ideas, priorities and thoughts. This is a proactive way to begin each day, rather than reactive.

When you wake up and just before you sleep is when the brain is at its most impressionable, therefore try to avoid looking at depressing newsfeeds during these times. These are the most powerful manifesting periods, so you want to have strategies in place to make sure you are consuming positive, uplifting and inspiring information in order to give you a good head start for a positive and creatively productive day.

One of the fundamental traits of a creative mindset is to notice the difference between when you are passively consuming information compared to actively engaging with ideas that you encounter. There is a difference between those who write down word for word what the teacher says in class and those who listen, assimilate and form their own ideas.

Similarly, obsessively following people on social media is wasted time when you would be better off

having your own experiences and interacting with real people. Have fun in the real world rather than narrating your life through a screen.

Begin your journaling from a place of curiosity and wonder, and see where it may take you.

Ten Tips for Journal Writing

1 Keep your journal with you all the time, so you can jot down things as they come to you during the day.

2 Find five or ten minutes of quiet time every morning and evening to write down your thoughts.

3 Choose a subject you mentioned in a previous day's entry and explore that idea at a deeper level.

4 Use the same pencil or pen each time and get used to the way it writes on the paper.

5 Make a note in your calendar of the days you have written in your journal until it becomes a daily habit.

6 Put in some prompts around your home to remind you to keep up your journaling. The fridge and your writing desk are good places.

7 Leave your journal and pen/pencil near your bed so that you are reminded to pick it up in the morning or before you go to sleep at night.

8 Date each page, including the year, so you know when you wrote it and have a sense of how things are evolving. It's interesting to look back on a year or so later.

9 Keep your journal in a safe and private place. Even get a book with a lock and key if you are concerned that someone may read it who shouldn't.

10 Don't edit yourself. If you feel like writing something down, go for it.

EXERCISE: LIFE DESIGNING

In your journal, draw a large circle on a
blank page and divide the circle into sections
and areas like this:

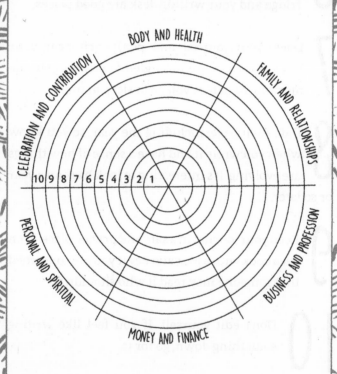

BODY AND HEALTH

FAMILY AND RELATIONSHIPS

CELEBRATION AND CONTRIBUTION

10 9 8 7 6 5 4 3 2 1

PERSONAL AND SPIRITUAL

BUSINESS AND PROFESSION

MONEY AND FINANCE

Mark out of ten how well you are currently doing in each area of life, where one is where you feel you are just scraping by, five is doing satisfactorily with some room for improvement and ten is optimum level, where you feel you are getting maximum results.

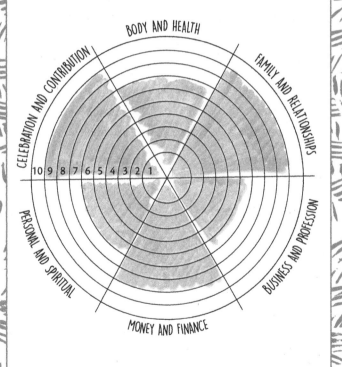

Use journaling to freely explore how you could improve your score in each area. What habits could you instil? What behaviours do you need to change? What obstacles do you need to overcome?

Doing this exercise will provide an immediate snapshot of where you are in your life. It will enable you to feel grateful for what is going well and also identify areas that may need some work.

It's important to ask the big questions about life every so often, to make sure that what you are doing every day is taking you in the right direction.

Consider these five questions and write down what immediately comes to mind:

1. Why am I here?

2. What's my mission?

3. What's important in my life?

4. What am I meant to be doing with my life?

5. What impact do I want to make on the world?

It may be that living a life with complete integrity or wanting to create something new to help the world is very important to you. Or it may be that you want to leave a lasting legacy, providing something useful or better for future generations.

Whatever is important to you, take notice of it and be aware of it, so you can build a life that reflects your vision and values.

When you ask these big questions, it will remind you to live out your deepest purpose; not to be too busy doing the small stuff to think about the big stuff. Get on track with regular journaling and follow your true mission.

Habit 3

MEDITATION AND BREATHING

'You should sit in meditation for twenty minutes every day – unless you're too busy, then you should sit for an hour.'

Zen proverb

Meditation is no longer an 'out-there' concept; it is beginning to be better understood and accepted as part of everyday life and is now practised in wellness spaces in many cities around the world. Indeed, it is believed that globally between 200 and 500 million people meditate today.[1] It is one of the daily habits of highly creative people – from David Lynch to Paul McCartney, Oprah Winfrey, Lady Gaga, Stephen Fry and J.K. Rowling, among many others – and for good reason.

It certainly saved my life. Some time ago I went through a major meltdown. My long-term relationship broke down beyond repair and we were told that my beloved mother was dying of cancer. I was finding

it difficult to focus on my work and sank into a deep depression. I didn't feel like I could function properly and didn't want to go out or see people. I couldn't imagine a future, but I knew I had to find a way to ride out the storm, because I had a child who depended on me.

A friend came over to see me and I told her how I was feeling. She had experienced her own trauma in her life, having had cancer when she was twelve years old, which led to her having one of her legs amputated to stop the illness spreading further. She has been in pain every day of her adult life and uses crutches to get around. But despite all this, she is one of the most fun, artistic and upbeat people I know. I asked her what her secret was, and she told me it was Transcendental Meditation® (TM). This started me on my own journey, and it has been the single most important tool that I have learnt in my life.

The first time I meditated I felt a unique sensation, like fireworks being let off in my head. I felt there was a release of pressure – it was as though I had been bottling it up for years without even realising it was there, until it was gone. I felt liberated and instantly more at peace.

That was over two decades ago, and since then TM has been an important part of my daily routine.

It's the time when I get most of my ideas and inspiration and is a sacred part of my day. In this chapter, we are going to dive deeper into this mystical state of being and understand how you, too, can use it to boost your creativity.

What is meditation?

Meditation is a mental process that involves relaxation, focus and awareness. Originally, the word 'meditate' meant to think deeply about something, but the contemporary meaning is to focus attention rather than reflect deeply. It is an individual practice, even if done in a group environment. It usually involves closing your eyes and being still, although there are some that include movement, such as walking meditations.

The practice is typically based around one of three methods: concentration, observation and awareness. Concentration is utilised by focusing on a single object, internal or external, and this is called 'focused attention meditation'. Observation is about paying attention to your experience in the present moment, without allowing your attention to get stuck on something in particular, such as specific thoughts. Awareness methods are about allowing your

awareness to gently rest on the moment and remain present, without being distracted or trying to focus on or observe anything.

Meditation brings with it a mental calmness and introspection. It is different from other forms of exercise, such as affirmations (where the objective is to imprint a message on the mind), relaxation (when the body is allowed to rest and release tension) or breathing exercises, such as pranayama, where the focus is on a certain kind of breathing to release toxins and purify the body.

The benefits of meditation

We have become a busy, stressed-out society and it is easy to tell ourselves that we don't have the time to sit down quietly for twenty minutes a day. But we must. Meditation is easy, free and open to all, and its benefits are well documented. Indeed, there are over 3,000 published scientific studies that point to the profound effects of regular meditation practice and its positive influence on our health and general wellbeing. It helps us to connect with ourselves from the inside and to gain power over our minds, which in turn affects every aspect of life.

Meditation helps to:

★ **Stabilise your emotions:** When you start meditating you will begin to feel more calm, centred and focused, and less fearful, worried, anxious and impulsive. Regular meditation lowers stress levels and depression, and helps to build self-esteem, increase awareness and improve mood and emotional intelligence.

★ **Sharpen your mind:** There is a lot of evidence that shows that meditation has a tangible positive effect on the amygdala, the part of the brain responsible for our emotions, our fight or flight responses and our memory. Therefore, regular meditation increases your mental strength and the amount of time you can maintain focus on a single subject. This in turn enhances your creative abilities and memory retention and recall.

★ **Generate better ideas:** Numerous studies have shown that when an individual or group of people meditates before a brainstorming session, the quality of the ideas increases significantly. You'll see that your ability to solve problems creatively improves, that you process information faster,

that you become a better listener and that you procrastinate less.

★ **Maintain a healthy body:** According to research by the National Institute of Health and the American Heart Association, daily meditation can lower your heart rate and blood pressure and helps lessen inflammatory disorders and asthma, while boosting the immune system and energy levels.

★ **Gain perspective:** Meditation helps you to see the bigger picture and not get distracted by unnecessary details. You will begin to notice how some thoughts are just getting in the way or are unimportant.

★ **Take a moment out:** Meditation helps us to stop unconsciously reacting to things happening around us, and to take a moment to pause and assess. You'll better notice the quality of your self-talk and whether you are spending your energies on positive or negative thoughts.

★ **Balance the left and right brain:** If you are a positive and resilient person, it's likely you are using more of the front left-hand side of your brain. If you are an anxious and fearful type, it's

likely you will be using more of the front right-hand side of the brain. Research carried out at the University of Wisconsin and Stanford found that after using meditation techniques for two months, their test subjects showed a significant rebalance of activity between the left- and right-hand sides of the brain, together with a corresponding shift towards a happier and more positive outlook on life.[2]

It's not just adults who can benefit from regular meditation practice. The David Lynch Foundation has funded the teaching of TM to over a million kids, veterans, at-risk groups and survivors of abuse in the US and worldwide. It is a far more natural way to help vulnerable kids than medicating them with drugs that can be addictive and have negative side effects. Research undertaken with school students who had been practising TM meditation showed:

★ 10 per cent improvement in test scores

★ Higher levels of happiness, focus and self-confidence

★ Reduced ADHD symptoms

★ 86 per cent reduction in school suspensions over two years

★ 40 per cent reduction in psychological distress, including stress, anxiety and depression

★ 65 per cent decrease in violent conflict

★ Healthier lifestyle with good eating practices

★ Slowing down of the ageing process[3]

★ Enhanced cardiovascular and immune health

★ Increased mental strength and recall[4]

The different types of meditation

There are many different types of meditation, incorporating practices from different traditions, cultures and spiritual disciplines. However, the form of meditation you do is not important – finding a way to practise quietening the mind, and making that a habit, is what matters most. There are plenty of resources on the internet, such as Live & Dare, where

you can find out more about the different methods, and here is a brief summary of some of the types I have personally tried:

Transcendental Meditation®

Transcendental Meditation is a simple meditation technique that involves sitting comfortably in a chair with your eyes closed. Like many styles, it does not involve any specific religion or philosophy. The basis of this technique is a process that involves transcending thought itself and experiencing a state of 'pure awareness'. It encourages the mind to go beyond surface-level thinking towards silence, concentration, focus and control, as well as towards a sense of greater freedom and creativity.

The TM technique was revived in India and brought into the mainstream in the 1950s by Maharishi Mahesh Yogi. It uses a specific mantra (an ancient sound given to you by a qualified teacher), which is said to liberate the mind, rather than actively train it, allowing your consciousness to settle effortlessly into silence. Because it involves utilising a mantra that is specific to you, it is not possible to learn TM from videos or an online course. You must instead seek out an

accredited TM teacher. This is the form of meditation that I have used for years.

Zen Meditation

Zen meditation is usually practised seated on the floor with legs crossed, traditionally in a half-lotus position. This method either requires focusing on the breath, exhaling and inhaling, or involves just sitting, without any object to focus on, and observing what passes through the mind, without dwelling on anything in particular. Zen meditation is often associated with Buddhist philosophy.

Guided Meditation

Guided meditation is a method that is often practised in groups or via an app such as Calm or Headspace. It involves someone guiding you through the process, and for this reason it is often an easier method for people new to meditation practice.

Loving Kindness Meditation

Also known as 'compassion meditation', this practice also comes from Buddhist traditions. It involves sitting with your eyes closed and connecting with your heart. You can do this by putting your hand on your chest and tuning into your heartbeat. Begin by feeling loving kindness towards yourself, then to others and all beings. Start focusing on 1) yourself, 2) a good friend, 3) a neutral person, 4) a difficult person and 5) all four of the above equally. The idea is to wish happiness on all beings, which in turn creates a warm-hearted feeling through your entire body.

EXERCISE: HOW TO MEDITATE

If you don't know how to meditate or you have tried it before and found it difficult, what follows are instructions for a simple form of meditation. (This exercise does not describe TM, which can only be taught by an accredited teacher.)

Start here

As you will need to close your eyes for this exercise, you may like to record these steps on a voice recorder and play them back to yourself while you go through each step.

Get comfy

Sit comfortably in a chair with your feet flat on the floor, keeping your back straight. It is best not to lie down, as you might fall asleep.

Set a timer

You may like to set a timer for your meditation. If so, set it for ten minutes to begin with (you can build up to twenty minutes when you are more experienced) and use a sound that will gently let

you know it's the end of the session. There is an app called Insight Timer that is ideal for this purpose.

Remove distractions
Make sure your phone is on silent and remove any other distractions.

Watch your breath
Begin to pay attention to your breath as it flows in and out of the body. Notice the feeling of inhaling, and as you exhale, release the breath gently without any force. Natural, gentle breathing is what we are aiming for. As you inhale, imagine you are breathing in inspiring ideas. As you exhale, imagine you are breathing out anything you are ready to let go of that no longer serves you. Keep your attention on your breath.

Let go of passing thoughts
You don't need to do anything. Just sit and notice your breath. Enjoy the sensation of having time for yourself. This is your time. Don't judge any thoughts that may arise while you are doing this. Simply let them come and go like clouds in the sky. Notice that you are not your thoughts.

Observe yourself

From head to toe, notice how your physical body feels in this quiet space. Are there any areas where you feel pain or discomfort? Do you feel peaceful and quiet, or are there lots of thoughts buzzing around? Simply notice what is going on without judging yourself.

Resist the urge to fidget

Keep your attention on the breath and just sit. You have nothing to do. This can feel unusual, so you may feel fidgety and want to get up and do something. Resist that urge. Keep sitting for the duration of the session, even if it feels uncomfortable at times.

Relax and stretch

Once your bell has signalled the end of your session, keep sitting for a couple more minutes, bringing your awareness slowly back into the room. Gently move your limbs and have a stretch. Notice how you feel – hopefully more serene, peaceful and calm.

Try to relax for another five or ten minutes after your meditation. Don't get up and immediately dive back into your day. Meditating releases stress and you may even feel sleepy. Give in to this desire and take a nap when you need to.

Avoid alcohol and caffeine, if you can, and keep well hydrated. Eat lightly after the session, rather than before.

Record your progress

It is worth keeping a note of how often you are meditating, as well as any insights or thoughts you want to remember after each session.

If you can, keep your practice to the same time and place each day – put it in your calendar and prioritise it.

Congratulate yourself

It's not always easy to find the time and space to meditate, so congratulate yourself for having done it. It is worth it and will reward you in many ways.

How to make time for meditation

I maintain that if everyone understood the power and potential of regular meditation, it would become as regular a habit as brushing our teeth. To instil a meditation habit into your daily routine, you may have to adopt some special tactics, such as getting up half an hour earlier, practising as soon as you wake up, marking out time in your diary, keeping a record of your progress or finding a meditation buddy who will hold you to account.

Start a group at work, school or college so that you all help each other get into the habit. You may find that group meditation amplifies the effects of the practice, making for a new and unique experience.

Getting deeper ideas

Meditation is an important tool for accessing new and unique levels of awareness, creating a space from where ideas, solutions and inspiration emerge.

I regularly use meditation to support my creative work. If I am going to write, I first begin by sitting quietly and meditating to make sure I am aligned in a flow state and accessing a stream of creative energy.

This habit informs my unconscious mind that I am about to start my creative work and helps me get connected to my intuition and deeper wisdom.

These rituals are important as they help our outer and inner worlds to start working together like magic. For example, when I walk into my writing studio and diffuse some good-smelling essential oils, I start breathing differently. I know I am about to enter the flow state and I start feeling a little excited about what I might produce. A smile often appears on my face as I arrive in my creative space.

Make your creative environment a pleasant place to be with happy and inspiring images on the walls, candles and uplifting or soothing sounds to add to your backdrop. (There are more ideas on how to curate the perfect creative environment in Habit 5: Self-care and Nourishing the Soul, page 125.) Fire up every one of your senses and the results will speak for themselves.

How to breathe

Correct breathing is crucial for keeping healthy and generating the optimum environment within your body to be at your best creatively. The word 'breathing' comes from the Latin word *inspiratus*, which is the

root of our modern word 'inspired'. Meditation helps to bring awareness to the breath and helps us regulate and improve the quality of the breathing process.

Breathing is natural and something we are born able to do, yet we rarely get it right. Although they don't know it, most people are either breathing too shallowly, from the chest rather than the diaphragm, or are holding their breath too much. Poor breathing can cause the following issues:

★ **Oxygen depletion:** The air passageways in the body get tighter, making it harder for the air to travel from the nose and mouth to the lungs. This results in less energy and puts stress on the body, meaning you also have to breathe faster.

★ **Reduced cardiac capacity:** The heart is constantly beating, around 100,000 times a day, and is a massive consumer of oxygen. If there are reduced oxygen levels, the heart can't pump the blood as efficiently. This can lead to poor circulation.

★ **The nervous system becoming unbalanced:** Your breath has an immediate impact on the nervous system, and a dysfunctional breathing pattern, like a short and forced one, results in tension and stress.

★ **Constricted blood vessels:** This can lead to higher blood pressure.

★ **Reduced cognitive function:** The brain uses 20 per cent of the oxygen we take in, so when there's a shortage of oxygen, the brain will work more slowly. Since the brain regulates every organ, all body functions are affected.

Breathing correctly is vital for achieving peak performance, the state we need to be in to access our most creative selves. We take around 25,000 breaths each and every day, so it's worth investing the time in perfecting your technique.

Meditation is one of the most powerful methods for activating creativity. By becoming a regular meditator, you will help all aspects of your inner self to work together naturally for maximum effect.

EXERCISE:
MASTERING THE ART OF BREATHING

1. **Breathe through your nose:** Every breath should come in and out through your nose, rather than your mouth. When the air flows through the nose, it gets filtered more thoroughly. Through the mouth, air arrives cold and dry, and is prone to contain more bacteria.

2. **Use your diaphragm:** As you inhale, feel the air travelling all the way down to your stomach. Aim for 70–80 per cent of your inhalation to be done by the diaphragm (just below the ribcage), rather than by your chest, in order to keep the breathing deep. This helps to work the lower parts of the lungs while the diaphragm massages the liver, stomach and intestines, keeping these organs in balance as well as aiding the lymphatic system to work efficiently in carrying waste products away from tissues and organs. Also, breathing from your diaphragm helps to lessen the pressure in the chest and belly, meaning the heart doesn't have to work so hard.

3. **Find your rhythm:** Be sure to breathe in a constant, stable tempo to keep the body calm and well balanced. Oxygen will flow at a steady rate, helping all bodily functions, including hormone production, to be in step with your natural rhythm.

4. **Breathe quietly:** Try to keep your breath quiet and gentle. Snoring, sniffing and breathing with great effort changes the pattern of your oxygen intake, which affects the body's balance.

Take time in your day to check you are breathing in the best way. When you manage the art of breathing, you will perform at your peak and operate in a space of high creativity.

5. Find your rhythm be sure to breathe in a
 and your..........your
 and well being.? Oxygen....flow at a steady
 rate....through all the connections, breathing
 and.....produce.....in......and.....your
 natural rhythm.

 made a......help keep your mind clear
 and......state.......with relaxed breathing, with
 clear......and.......consciousness......

 as....to.............
 ...the best way......on you........Short, Sing
 a.......and will power.....that you will feel

Habit 4

BOOSTING YOUR BRAINWAVE STATES AND MIND-MAPPING

'Logic will take you from A to B, but imagination
will take you everywhere.'
Albert Einstein

The human brain is a highly complex and powerful
electro-chemical organ. A fully functioning brain
generates around 10 watts of electrical power at any
time and is affected structurally by the thoughts we
think, the emotions we feel and the words we speak.
Alongside performing millions of mundane activities
that we don't even notice, it supports us in all our
artistic and creative endeavours, whether that is to
paint, draw, sing, dance, compose a symphony or
find solutions to mathematical equations. It is our
body's mission control and codes everything for
us in the form of thoughts and memories. It is the

home of feelings, behaviour, cognitive intelligence and experiences.

One of the habits of highly creative and successful people is their ability to effectively train their minds and to consciously harness their most powerful inner resource states to help them create their artistry. A 'resource state' is a term used in NLP that refers to a state in which a person has positive, helpful emotions and strategies available to guide them to a better place from the inside out.

In order to maximise your creative potential, it's useful to be aware of how the brain functions and its different neurological pathways. In this chapter, we will explore the nature of different brainwave states, and how to use them to best effect when you are on a creative mission.

The different brainwave states

We may feel more creative at certain times of day – this is because we move in and out of different brainwave cycles throughout the day.

At the root of all our thoughts, emotions and behaviours is the communication between neurons. Brainwaves are produced by synchronised electrical

pulses from masses of neurons communicating with each other.

There are five main categories of brainwaves, known as delta, theta, alpha, beta and gamma, and they all have different effects and functions to support us:

DELTA (0.5–3Hz)

This is the slowest brainwave state, generated in deepest meditation and dreamless sleep. In this state, awareness is suspended and the deep healing and regeneration of cells occurs.

THETA (3–8Hz)

We enter a theta brainwave state when we dream. This can occur while you are asleep and also when daydreaming – when you drift off into a gentle and calm space with a free-flow of ideas. It is typically a positive and creative brain state, often associated with receiving vivid imagery and information beyond normal conscious awareness. It is a gateway to increased learning, memory and intuition, and in that way holds potential for enhancing creativity.

ALPHA (8–12Hz)

Alpha waves represent a non-engaged state of mind. This could be when you have finished a

task and then stop to rest, or when you take a walk into nature. It is a resting state for the brain. Alpha is associated with a tranquil, pleasant, floating feeling and is the brainwave state for receiving insights, ideas and inspiration. Neuroscientists recently made a connection between an increase in alpha brainwaves – either through mindfulness and meditation or through electrical stimulation – and the ability to increase creative thinking and reduce feelings of depression.[1]

4 BETA (18–30Hz)

Beta is a 'fast' wave activity that is present when we are alert, attentive, focused and engaged in problem-solving or decision-making. These are the fastest brainwaves in terms of speed and they dominate our normal waking states of consciousness.

5 GAMMA (25–100Hz and above)

Gamma waves occur when we simultaneously process information from different areas in the brain, and this state has been associated with higher states of conscious perception. The gamma brainwave helps bond all our senses and what they perceive, bringing a sense of oneness. This is also known as a state of mental awakening, represented by a feeling of

sharp focus and a sense of being present in the moment.

How to boost your brainwaves to get into a higher state of creativity

As you can see, the various brainwave states have different functions and effects. We move through the whole spectrum throughout the day, though some will be more dominant than others, and we need them all as they work together to produce the widest range of human emotions, perception and capabilities.

Here are four very simple ways that you can boost your brainwave states for the better:

Make good choices about who you spend your time with

It's useful to think of the mind as a radio transmitter, sending out waves to others around us. Our brain's frequency will synchronise with the people we spend most of our time with, which is why it's wise to avoid toxic people who suck our energy. Instead, it's a good idea to spend time with those who inspire and encourage us and are leading a creative life themselves. This is also one of the reasons why nature can be so uplifting – we are surrounding ourselves

with the natural and powerful energy of the trees, plants and animals.

2 Eat well

Look at your diet and be aware of how food makes you feel. Does the food you eat power up your energy or leave you feeling depleted?

Food creates a chemical reaction in the body and can be a disruptor of brainwave states. Make sure that you are eating a good range of fresh, colourful, natural foods to support your body's systems; this will help you to stay healthy, strong and alert. (There is more about this in Habit 5: Self-care and Nourishing the Soul, page 125.)

3 Clean up your words, thoughts and actions

As we have already explored, your words, thoughts and actions have an impact on your internal frequency and natural health.

Japanese author and scientist Dr Masaru Emoto observed the effects that different words, emotions, music and environmental factors had on molecules of water in a series of famous experiments conducted throughout the nineties. He exposed water in glasses to different words, speech and thoughts, and found that when the water was exposed to positive ones, the molecules would form pleasing shapes when frozen.

Negative words, thoughts and emotions created ugly frozen formations of the molecules. This, among other findings, led him to conclude that water was a blueprint for our reality, and that emotional vibrations changed the physical structure of water.[2]

Given the fact that the human body is made up of over 60 per cent water, it follows that we are hugely affected by the nature of the words and thoughts we use – both positive and negative. Therefore, if we are to harness our full creative potential, we should be mindful of what we say and do.

4 Meditate

Meditation, which we explored in the previous chapter, helps the brain to enter into the theta brainwave states, where deeper insights, intuition, spiritual connection and creativity are commonly experienced.

5 Daydream

We can sometimes think of daydreaming in a negative way – as though we have 'switched off' or have our 'head in the clouds' – but it is an important tool for boosting creativity. When we allow our minds to wander, we access more meditative and relaxed brainwave states, where true inspiration can flourish

and flow. This is the space where we will find our real creative spark, tune in to new ideas and experience that 'a-ha' moment of hitting upon a creative solution to something.

EXERCISE: HOW TO DAYDREAM

1. Choose a real-life goal that you want to achieve in the next twelve months.

2. Close your eyes and imagine pursuing that dream as vividly as you can. See yourself working towards it and being successful every step of the way. If you come across obstacles, don't ignore them but see yourself finding a way around them until you imagine reaching the final goalpost. Spend about twenty minutes on this process.

3. Imagine yourself having completed your goal with ease. Make it happen in your mind's eye as though it's real and pay attention to the feeling that arises in your body.

4. When you have finished, gently open your eyes and have a five-minute rest, then gather yourself before you continue with your day.

Try to build daydreaming into your daily practice. Get reflective, dream and build glorious visions in your mind.

MY DREAMS...

EXERCISE: USE YOUR BRAINWAVE STATES FOR CREATIVE ADVANTAGE

1. Choose one task that you need to get done – something you have been avoiding or procrastinating over. It might be a tricky conversation, a work project or a book proposal you want to get finished.

2. Write it down in your journal and leave it by your bed before you go to sleep. In your sleep state, unconscious thoughts will rise to the surface and new ideas will lodge in your conscious mind.

3. As you wake up in the morning, keep your eyes closed, stay in your dreamy theta brainwave state and think about the task in hand. The theta brainwave state is the most fertile for idea generation and manifestation. Let your mind go freely with it and don't force anything.

4. Grab your journal and write down any ideas that come to you. As easily as these thoughts come to the surface, so they can vanish into the ether. Record them, consider them and then act on them if it feels right to do so.

Albert Einstein and Thomas Edison relied on these half-asleep moments to work on their biggest ideas. What worked for Einstein can work for you.

Building powerful resource states

It's no coincidence that Olympic training teams have mental coaches alongside performance coaches. That's because top-level athletes know the importance of building mental strength as well as physical strength. Being able to access a powerful resource state is one of the fundamental skills in any successful training programme and will help to put you in the right frame of mind for achieving your creative goals.

Before you begin your next creative task, practise getting into one of the following ten positive resource states. First, choose the states that resonate most with you. Once you have mastered one, try another. Then imagine stacking these powerful states on top of each other to boost the effects.

Excitement
Think back to a time when you felt excited about something. Run the memory again in your mind, in as much detail as possible, and notice how that feeling spreads through your body. Remember your posture, the thoughts you had, where you were, any smells or other senses that are tied up with this emotion.

Now squeeze your thumb and forefinger together as you remember that feeling of excitement. Hold it

between the tips of those two fingers. This is an NLP technique called 'anchoring'.

You can return to this state anytime you want to by going back into that memory and squeezing the two fingers together again.

2 Curiosity

What makes you curious? What interests you? What would you like to know more about? When did you feel most curious recently? Were you curious as a child?

Return to that feeling of curiosity and recreate that feeling now in your body. Once again, anchor that positive resource state by squeezing your thumb and forefinger together.

3 Strength

Remember a time when you felt strong. What precisely did you feel? Where did you feel strong in your body? What activities make you feel strong? Remember how that felt. Change your posture to reflect that feeling. Run the memories in your mind's eye and now squeeze your thumb and forefinger together to anchor the feeling to that action.

4 Passion

What do you feel passionate about? Who do you feel passionate about? What would you like to feel passionate about?

Access that feeling, notice where in your body it originates from and give it a colour. Imagine that colour spreading through your body as you squeeze your thumb and forefinger together to anchor the feeling.

Find something to feel passionate about that you are going to do today and amplify those feelings by accessing these memories and squeezing those fingers again.

5 Flow

Can you remember an instance when you really felt in the flow? An occasion when you lost all track of time and space because you were so absorbed in what you were doing? Again, anchor that feeling by squeezing your thumb and forefinger.

Before your next creative session, reactivate that memory by squeezing the same fingers. Get mentally engaged with what you are doing and feel the flow in your body.

6 Confidence

When do you feel most confident? At work? Teaching something that you are good at? In the gym or while you're relaxing with some good friends? Remember a time when you felt confident and recreate the feeling. Bring it back into your awareness and spin it around your body. Let the feelings permeate your cells and awareness. You can choose to anchor this with the thumb and finger technique if you wish.

7 Childishness

Think back to when you were a child. See if you can remember the feeling of being free to be yourself, naive and experimental. When you were allowed to play and be silly, dress up, and say what you thought without caring too much about what people thought of you. Silliness is a great place to be to create new things and get into your creative zone. It helps dissolve barriers about the way things should be done and brings waves of new possibilities.

Anchor that feeling with the thumb and forefinger technique and access that state more often.

(If your childhood was difficult or traumatic then avoid this exercise.)

8 Flirtation

Remember a time when you were flirting with life or with someone you really liked. Allow a smile to spread over your face. Replay that feeling and remember what love feels like. You can use the thumb and finger anchoring technique here too if you choose.

9 Clarity

Remember a time when you were feeling absolutely clear about something. It may be when you decided on a new job, a new relationship, buying a house or getting a car that you wanted. You just 'knew'.

This state of certainty and clarity is useful for getting into the creative zone. If you know for sure that you want to write a book or start a painting, access this useful resource state and dive in. But do start small. The job will get done if you approach it with one manageable step towards your goal at a time. Anchor that feeling with the anchoring technique and replay that feeling whenever you wish.

10 Playfulness

Playfulness is a powerful state. It corresponds closely to childishness yet is a little different. When we become playful, there is more lightness and a carefree approach in our behaviour. When being playful, we don't care so much about winning. It's more about taking part and enjoying the process.

Remember how good it felt to play as a child, and let your imagination run wild. Remember how it felt to dress up like superheroes or fairies or dragons. Allow yourself to access this feeling now, because when we play, we enter the flow more quickly. The more you play, the more you allow your inner creative child to come to the surface. The anchoring process will work with creating this feeling as well and give it greater power.

The power of music

Listening to music is another great tool for evoking strong mental resource states. A 2017 study conducted by Simone Ritter and Sam Ferguson for the Netherlands Organisation for Scientific Research (NWO) explored music as a source of creativity.[3] In the experiment, subjects were given creativity exercises while one

group was exposed to silence, the others to classical music that evoked one of the four emotional states of happiness, calm, sadness and anxiety.

Each group was given creative exercises designed to measure divergent or convergent thinking. Convergent thinking narrows down multiple ideas into a single solution, whereas divergent thinking expands outwards, generating multiple ideas – and because of this, it is an important mental state for creativity.

It was found that the group who listened to happy music demonstrated better divergent thinking than those who had worked in silence. They came up with more ideas in total and more creative innovations. It follows that listening to happy music helped enhance the cognitive flexibility needed to come up with innovative solutions and new perspectives.

The other types of music evoking calmness, sadness and anxiety did not have the same effect, and none of the music had an impact on convergent thinking. It made no difference whether the subjects liked the music or not.

The results of the study show that the happy mood generated by listening to that type of music is a powerful way to boost your creative prowess. So, play a piece of music you love, turn up the volume and allow

MY FAVOURITE SONGS . . .

yourself to dance. Don't worry about what anyone else thinks. Dance like no one is watching.

Neuroplasticity and creativity

Our minds are infinitely powerful and flexible. We have the power to adapt to new experiences and learn new skills on an ongoing basis. As we do so, we make new neural pathways in the brain in a process called neuroplasticity.

With every thought and emotion we experience, we reinforce a neural pathway inside the brain – and begin to create a new way of being and feeling. These small changes, when frequently repeated, lead to changes in how the brain actually works.[4]

Neuroplasticity is the 'muscle-building' aspect of the brain; the things we do often, we become better at, and the skills we don't use so often fade and deteriorate. We literally become what we think and what we do most regularly.

Therefore, the more creative endeavours we undertake – whether it's writing, making music, dancing, designing or drawing – the more hardwired for creative success we are going to become.

Mind-mapping

Mind-mapping is a very powerful creative skill. I use it with many of my clients to help them formulate a road map of where they want to go with their creative projects. It's a very useful tool to help structure, organise and bring ideas into view and then into reality.

With a mind map, it's easy to look at the bigger picture and to spot connections between topics and subject areas that would not be so easy to see if they were set out in a linear list. You can add ideas in any order and keep building upon them. They don't need to be placed chronologically, meaning it feels like a more organic and naturally evolving process.

As you add ideas you can discard any you don't like and reorder the ones you want to keep. It's infinitely flexible and gives you a visual blueprint of your thoughts, allowing you to organise different concepts. It's a good idea to use lines, symbols, words, colours and images, as the brain tends to remember and analyse information more easily when presented in a visual and colourful way. In the end, a completed mind map resembles the structure of cells in our body, with a nucleus in the middle, around which everything else is formed.

Dr Roger Sperry won a Nobel Prize for his research, which showed that the human cerebral cortex is divided into two hemispheres – the right and left brain – with each side performing a specific range of tasks. These tasks were identified as logic, recognising lines and colour, making lists, daydreaming, imagination and an ability to see the 'whole picture' at once. Mind-mapping uses both left and right brain-thinking, helping you to experience greater clarity, create a big-picture structure and be organised. It also uses memory and imagination, as well as association and location, providing the ultimate planning tool that utilises all the significant ways of thinking in one approach.

For every book I write, I start with a mind map. More precisely, I begin with a few mind maps addressing different questions that together will give me a perfectly planned road map to completion. In this way, a mind map becomes a schematic drawing that tells you how to reach your destination.

There are some great apps you can download to help you mind map on your computer, such as Scrapple (designed for writers, simple to learn), Ayoa (developed by Tony Buzan, the originator of mind-mapping), MindMeister (easy to learn), Mindly (good for using on phones) and MindNode (a simple mind-mapping tool with plenty of flexibility). Try a couple out first to see which one suits you best.

Now, let's get started.

EXERCISE: HOW TO CREATE A MIND MAP

For this exercise, we're going to imagine that you want to write a book, but you can apply the following principles to any creative project you want to start.

Get some coloured pens and an artist's sketch pad (landscape, A3 size works well) with blank paper, not lined. Alternatively, you can use one of the many mind-mapping software programmes available (see opposite page).

Before I create a mind map, I like to meditate first for about fifteen minutes or so. Sit down in a quiet space, close your eyes, keep your back straight and your feet on the floor. Quieten your mind and access that deep creative well inside you.

Open the sketch pad and when you're ready, in the centre of the page, draw a circle and write inside it the central theme or project name for your mind map. Add a picture to represent the theme.

Draw lines coming out from the central circle, where you will answer some key questions

about your project. If you are a writing a book, for example, the questions you include may be something like these:

★ What are the key themes of this book?

★ How are the chapters organised? What is the content plan?

★ What's a good title?

★ What is the format (style, voice, structure)?

★ Who will want to read it (audience, age group, gender, interests)?

★ Why should I write this book? What are my unique credentials?

★ Why does this book need to be written? Why is it unique?

★ What other books have inspired me to write this one?

★ What other source material will I use?

★ What other experts do I need to contact or bring in to help me?

★ What other books like this exist in the market, and how will mine be different?

★ How will I market my book (the positioning, PR, social media, press and building my platform)?

★ How much time each week will I dedicate to writing? How will I find the time to do it?

★ When will I write and how long for in each session?

Write down the questions that are relevant for your idea or project and work with your own set of questions to create a mind map.

MIND MAP

Why now?

What time can I dedicate
to the writing process?

WHEN?

Positioning

PR and promotion

HOW?

BOOK PROJECT:
THE BASIC ELEMENTS

Other books

Other source material

Other experts

How this book is different

INSPIRATIONS

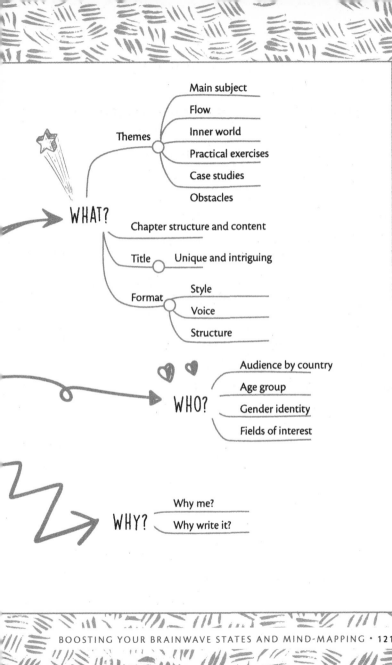

Themes
- Main subject
- Flow
- Inner world
- Practical exercises
- Case studies
- Obstacles

WHAT?
- Chapter structure and content
- **Title** — Unique and intriguing
- **Format**
 - Style
 - Voice
 - Structure

WHO?
- Audience by country
- Age group
- Gender identity
- Fields of interest

WHY?
- Why me?
- Why write it?

Five tips for creating a powerful mind map

1 **Keep the branches as brief and simple as possible:** This will help you to create more associations and links between each idea than if you use longer or more complicated phrases.

2 **Use key words:** Limit the words coming off each branch to key phrases, as this helps to break the information down into its simplest form. Using keywords will help your brain to recall and connect a broader range of ideas together in a more creative way.

3 **Colour-code the branches:** Using colour helps the brain to code information – categorising, highlighting, analysing and identifying connections that you may otherwise not notice. Colour-coding links the visual with the logical and helps the brain to create more shortcuts to creating new ideas.

4 **Add images:** Pictures convey a lot of information quickly and act as a good way to recall details.

5 **Don't overload the page:** Keep some white space so that once you've finished your mind map, you can make connections between the different ideas using lines and arrows.

Use this mind map like a road map to find your way to the destination of your creative project. It will help you to find clarity and focus, and to generate plenty of fresh ideas and new connections. Remember to enjoy all the steps – there are no right or wrong answers. It's your map and your design.

Habit 5

SELF-CARE AND NOURISHING THE SOUL

'Self-care is the opportunity to refuel so that we can give more to the world outside us.'
Jayne Hardy, *The Self-care Project*

When it comes to self-care, we have come a long way in recent times, as the pressures and pace of modern life have put a spotlight on the importance of nourishing our mind, body and soul.

As the world speeds up, it's time for us to slow down, observe more, do less and put ourselves first. Yet that is easier said than done. Many of us struggle to achieve a good balance between work and leisure time, spiritual practice and physical exercise. It is no coincidence that the most highly creative and successful people I've met prioritise their own wellbeing and that of their family above everything else.

With some simple steps and small adjustments, you can live a more harmonious life, and feel your soul, body and creative output working in greater harmony together. This chapter will show you how.

Slow it down

△▽△ ▽ △▽△▽△ ▽ △▽

When we actively make the effort to slow down, we give our bodies the time and space to decompress and relax. In this state of calm, you will observe the details of life more closely. Things don't speed past us so much and we get to savour and enjoy the small moments. This is when ideas come to the surface and we find ourselves getting creatively inspired – and this is where the real joy of life can be found.

When we engage in simple external tasks that allow the mind to wander, such as washing the dishes, going for a walk, meditating, cooking a meal or relaxing in the bath, the mind becomes more relaxed and therefore better at creative problem-solving. I'm sure I'm not alone in having had the experience of going for a walk and having new ideas drop into my mind like magic. When we are involved in activities that take our mind away from everyday problems, we become more present in the moment.

If you don't have any moments like these to savour in your day, then you can be sure you've got too much going on. You need to find ways to rid yourself of tasks on your daily to-do list so that things feel more manageable and enjoyable.

EXERCISE: KEEP TRACK OF HOW MUCH YOU DO

Do you feel like you are trying to pack in too many things every day? If so, grab your journal and start making a note of what you do on an average day.

Do this for a week: every evening, write down exactly what you have done that day. At the end of the week, reflect back on that list. Are you busy all day, every day? Do you have any downtime each day? Is there one day a week where you can relax, kick back and rejuvenate? Is everything you do each day important and necessary? What could you cut out or add in to make your days more fun and enjoyable? How are you feeling each day: tired and exhausted, or energised and excited by life?

If you're amazed at how much you manage to pack in, then take a step back and work out how you can build some downtime into your calendar. Schedule time for self-care like you would plan an important meeting. Aim for at least three self-care sessions for yourself each week – whether that's a trip to the gym, a massage, a lie-in or an afternoon on the sofa reading a book with no

other commitments. You are in charge of how you spend your time, so make good choices. There is no getting it back – once it's gone, it's gone.

Talk to your partner and family about this, too, so they understand why you are doing this and can support you. Encourage everyone in your circle to value downtime and make it part of their routine. Children need even more downtime than adults. It's key to keeping everyone healthy, happy and in good spirits.

After a month, you will start to value this time as an important part of your overall wellbeing. Don't forget that in this space you are more likely to be creatively inspired, so remember to jot down your ideas in your journal as they arise.

Get more sleep

No one can operate at their best without enough quality sleep, and so many of my clients tell me that lack of sleep is one of the main barriers to accessing their most creative selves.

I understand; it can be difficult to switch off from the day's events, or sometimes you wake up in the night with thoughts buzzing around your head and then find you can't get back to sleep.

A good night's sleep is so important for cellular rejuvenation. It's when the body repairs itself and the events of the day are processed and stored in your memory. Sleep helps to keep the heart healthy and regulate blood-sugar levels, and plays a big role in processing emotions. If you get less than six hours of sleep at night, you are at a greater risk of developing disease and are more prone to bad moods and depression.

I live in Spain where it is common to take a siesta in the afternoon, when it is too hot to go out in the afternoon sun. The shops and banks close at around 2 p.m. until 5 p.m.; a quiet hush descends upon the towns and villages as people head home for lunch and a nap.

I grew up in England and taking a mid-afternoon nap was not part of my normal routine there, but

when I arrived in Spain I decided to give it a try. Now I wouldn't be able to function without my forty-minute siesta. I get less tired generally and maintain a good level of energy throughout the day, enabling me to access my most creative self more easily and for longer periods of time.

The Benefits of Napping

★ Greater relaxation for the mind and body

★ Reduced fatigue

★ Increased alertness

★ Better mood

★ Improved performance levels throughout the day

★ Faster reactions and memory recall

I know that in the UK, for example, it is less socially acceptable to slope off for an afternoon nap. If you try to do that in most workplaces you would receive a lot of negative feedback. However, there are many

co-working spaces popping up that have areas where you can lie down, relax, take a nap or meditate in order to help you increase your overall efficiency. This is simply about working smart and it is one of the habits of highly productive people. Try weaving it into daily life and see how it works for you.

The world is waking up to the power of sleep: don't feel afraid to take advantage of such spaces in your own workplace. You may be the one to set a new trend!

Five Ways to Ensure a Good Nap

★ Keep daily naps to the same length, around twenty to forty minutes maximum, and around the same time each day.

★ Take naps early in the afternoon. If after 3.30 p.m., they can interfere with your night-time sleep.

★ Nap in a quiet place that is a comfortable temperature, where you won't be disturbed.

★ Keep a clock nearby to monitor the time. Turn off your phone.

★ Take ten or fifteen minutes after you wake to readjust.

Regular exercise

The physical benefits of regular daily exercise – increased muscle tone, enhanced cardiac capacity, lower blood pressure and fat loss – are well documented.

Exercise has a powerful impact on our mental health, producing endorphins that help us to focus and feel more alert, and increases energy levels and helps to reduce anxiety. The increase in heart rate promotes the flow of blood and oxygen to the brain, boosting cognitive function and helping us to be more creative. Regular exercise is also associated with better sleeping patterns and increases our natural sex drive, so it's a winner all round!

It's no coincidence, then, that successful creatives tend to exercise more. Speaking to GeekWire, Richard Branson, founder of the Virgin Group, said, 'I wouldn't be able to achieve all the things I was trying to achieve in my life if I wasn't at the peak of fitness.'

But in our busy lives, exercise can sometimes be a low priority. Here are some tips to help you get into a regular habit:

Train with a partner: If you arrange to exercise with someone, you are far more likely to show up.

Set a realistic goal: How often can you train each week? Decide your goal (ideally you would aim for around three moderate-to-intense workouts per week), share it with your friend and come up with a plan to support each other to meet this target.

Find the best time of day for you: The morning is ideal for me as other things don't get in the way, but decide what works for you and then schedule it in your diary.

4 **Do what you enjoy:** Make exercise fun. You don't have to join a gym if that doesn't appeal to you. Take a fast walk around a park during your lunchbreak, walk up the stairs instead of taking the lift or get off the bus a few stops early.

5 **Keep it varied:** It's easy to fall into a rut and for exercise to feel boring and become a chore. Keep yourself engaged by varying the exercise you do. Perhaps you could try a spinning class, take up swimming or boxing or go for a hill walk with a friend. Personal trainers are also a great way to keep yourself motivated and on track.

6 **Keep a record:** Add a note to your calendar so that you can see how well you are doing. If you miss a day, it will help you identify why and come up with tactics to help you stay on track.

7 **Keep a gym bag ready to go:** Carry it with you so you are always ready to exercise when you get a moment.

Eat well

△▽△▽

Food is fuel and our performance and emotional wellbeing is hugely affected by what we put into our bodies by way of sustenance. Food affects the way we feel because of the chemicals produced when we digest what we've eaten. Small changes in diet can make a big impact on our energy levels and vibrancy, which in turn affects our ability to be the most creative version of ourselves.

When we eat mindfully and with awareness, we make different decisions about what we put into our body, and when we bring awareness to the meal in front of us, we are better able to absorb the nutrients and digest our food properly. That is because signals are sent to our digestive system via our senses, so taste, smell and take a good look at the food you are eating. Relax for ten minutes after eating to allow your digestive system to do its work.

As the saying goes, 'you are what you eat', so choose food with a life force to it. Eating simply, cutting out refined and processed foods, and filling your diet with fresh, wholesome food will make you feel better and think more clearly. I cut out refined sugar after reading about the increased links to cancer. As a cancer survivor myself, being aware of the relationship between the

two made it easier for me to focus on where and how I was consuming too much refined sugar, and then to make conscious alternative choices. I noticed that when I was consuming sugar, I would experience highs of energy followed by a crash. Cutting out sugar stopped these lows and has allowed me to feel more evenly balanced throughout the day.

In the morning, I drink pure lemon juice in water, which helps to balance the body's pH levels and gets your digestive system moving. According to Ayurvedic medicine, the sour taste of lemon stimulates the *agni*, your internal fire, which helps to jump-start the digestive system, enabling better absorption of vitamins and minerals while preventing the build-up of toxins. Lemons are also high in vitamin C – a primary antioxidant that protects cells from damaging free radicals.

Keeping well hydrated is also important to make sure that your mind is clear and sharp. Curb the caffeine, kick out fizzy drinks and aim to drink at least 2 litres of good-quality water every day.

Keep your emotional world in balance

Although we can't control what goes on around us, we can control how we react to it. Make a conscious effort to tune in to high emotions such as love, laughter, happiness, appreciation, gratitude and pride, and steer away from low emotions such as hate, greed, lust, envy, guilt and irritation, which will throw your emotional state out of balance.

Some of my clients have told me that they believe they need to experience deep sadness or a crisis in order to motivate themselves creatively and add texture to their artistic work. I asked David Lynch what he thought about this: 'Sure, it's fine to go through things and bring the darkness into your creative work,' he said, 'but you don't need to dip down into it yourself. You can make art like that and be a happy camper. If you are an artist, you've got to know about anger without being restricted by it.'

Indeed, one of the greatest things you can do each day is find appreciation for what you have. Try to think of five things you feel grateful for each day; these can be simple things such as having a close group of friends, a loving family, enough food to eat, freedom, a roof over your head.

This gratitude exercise will lighten your mood

and boost your emotional frequency. When you start noticing a few good things around you, this warm feeling will expand to support the idea that things are going well in your life overall.

Learn to say no

Self-care means standing up for yourself and being able to express what you do and do not want. One of the most powerful words we can use is 'NO'. Learn to use it more – turn down things that you don't want to do, and put up strong boundaries about what does and doesn't work for you.

Do not be afraid to speak your truth; if you are too tired to make a meeting, say so. If you would rather get on with a creative project than go out with a friend then tell them that. This is an important part of self-care: say what you mean and mean what you say. You will get strength from this, feel happier and have more time available for your creative pursuits.

WHEN I NEED TO SAY 'NO'...

Create a lifestyle that supports your creative self

Don't waste your life. There is no point in doing a job that you hate, or staying with the wrong partner, or spending time with friends who irritate you. We get one go at this life, so live it well. The world is full of opportunities, so give yourself permission to step up, make a change and design a life you love.

I lived in London for many years, where I felt stressed and unhappy and realised I was with a man I no longer wanted to be with. After some thought about my situation, I decided I was ready to make some big changes. I took my son out of school and moved to a warmer climate without a real plan. Friends and family tried to put me off and said I was making a big mistake. I know this was because they were worried about me, but I felt instinctively that this move was the right thing to do.

Fortunately, courage took over and it turned out to be one of the best decisions I have ever made. I now have a life that I love and don't need a holiday from. My son feels the same; he loves the changes in our lifestyle. He was offered a place at a school he enjoyed and we quickly found ourselves surrounded by a supportive and like-minded community, a new set of friends and

living a much happier life.

It's always possible to make changes to create a better life, even if it feels hard at the time. Trust me, your soul will thank you for it.

Cultivate a supportive community

Developing and nurturing a supportive community is one of the most important elements on the road to leading a successful creative life. Since early civilisation, the human race has naturally formed itself into groups, recognising that living in close proximity to others helps to form social frameworks that underpin a functional society. One of the downsides to modern living and working practices is that many people feel disconnected from others. You may have moved away from your place of birth, or you may work remotely and don't have much face time with real people in your daily life. Even modern town-planning practices have eroded a sense of community, with people crammed into high-rise apartment buildings where they don't know their neighbours and never talk to those who live around them.

Without an active and solid community around us, we can feel painfully isolated. We are hardwired

CHANGES I NEED TO MAKE . . .

to share our stories and communicate with others, and if this is absent, we can feel lonely, disconnected, unhappy and stressed. A strong community offers help, support, people to talk to and to share ideas and solutions with. Richard Branson attributes his success to always having good people around him as well as a strong family unit.

When social distancing became a necessary part of everyday life for many people around the globe due to the coronavirus pandemic, there was an increase in discomfort, fear and anxiety for large groups. We need that human interaction with others to feel safe and happy. It is one of the fundamental pillars for human beings.

In order to lead your most creative life, it is important that you allow yourself to connect with others, to be open to their ideas and skills and to surround yourself with a great community of artistic friends.

When I was diagnosed with a brain tumour, it came as a huge shock. I was living a very clean lifestyle, staying fit, not drinking alcohol or smoking cigarettes and eating a vegan diet. I had been exercising and meditating daily. A year later, after the diagnosis, I am writing this book, with two clear brain scans showing complete remission. I am back to full health with plenty of energy once again.

One of the most extraordinary things I found during my illness was the power of friendship and community. I had never felt support like this before in my life. As my family live in another country, I had to rely on friends and neighbours for help in daily life. The whole community came together to feed me, look after my house and take care of my businesses. This local community was also amazingly supportive to my family overseas, giving them daily updates on how I was doing. This gave me a huge amount of strength and enabled me to focus on getting through this health crisis. Without them, I would have felt very alone and vulnerable.

This experience made me realise how important it is to have valued people in our lives to talk to, interact with and ask for help when we need it most. This is important when it comes to developing a healthy creative life too.

To feel creative and empowered, we need to feel free and liberated to do our best work. To that end, it's important to build a community of friends who can help support you in your creative endeavours. If you have kids, that may mean getting help with school pick-ups or homework supervision, or sharing the cooking and household chores, to give you the time and space to focus on your project.

By asking for and receiving help, you will forge life-long friendships – giving and taking in balance creates a sense of belonging and love for everyone involved. This is part of what makes humans feel happy and fulfilled.

Curate your environment

It's important to surround yourself with a good physical space to do your creative work. It doesn't matter what the working space offers in terms of size, as long as it gives you a good feeling and inspires you to be creative. It may be an art or music studio, a writing shed in the garden or a particular space in your home. A pleasant, soothing environment will make you feel better and will mean that you are more likely to want to spend time there.

Busy, loud, noisy working spaces make it hard to stay focused or stay in a creative mood, so try to find a place that you love, surround yourself with objects that give you joy and get settled in. You're going to be spending a lot of time there.

How to Curate the Perfect Creative Space

Invest in a good chair, one that is ergonomically designed to look after your spine. Alternatively, choose a desk that gives you the option of sitting or standing. Studies show that people who use these kinds of desks are often more engaged in what they are doing and can work for longer stretches of time than those who sit for long periods.

Maintain a good temperature in your working space – not too hot and not too cold – with good air circulation. Try to create a pleasant view from your desk – hang pictures or photographs that inspire you, and add plants to bring some colour, oxygen and life into the room.

Make your creative space smell nice – burn some good-quality incense or essential oils. These are a great help for creating focus and clarity – for example, peppermint oil helps with maintaining focus.

Keep your space tidy, well organised and clean. Throw away anything you don't really need and set up a filing system so that those bits of paper

you do want to keep are put away where you cannot see them but where you can access them if you need to. Taking them off your desk will mean they won't keep distracting you.

5 **Put on some soft sounds or music if this helps you to relax.** On Spotify you can find playlists designed to help you focus, and there are apps such as Endel that give you specific soundtracks to help with work, sleep, relaxation or concentration.

6 **Switch off your mobile and email notifications.** You cannot stay in a focused, creative state with notifications coming through on your devices all day. Such constant bombardment can make us feel overwhelmed and distracted.

7 **Let people know you are in 'Do not disturb' mode.** Set a particular day and time of the week for your creative time and let everyone know that's when you are working and not to be disturbed.

8 **Take regular breaks.** It's hard to work creatively and with full focus for hours at a time. You will be more efficient if you take regular breaks of around five to ten minutes – move around and stretch

to get the blood circulating. You will come back to your work with a fresh perspective.

Looking after yourself and giving yourself and your surroundings the care you deserve is one of the most important aspects of living a healthy, creative life, abundant with energy. Self-care is good for the soul. Once you have mastered it, you can achieve anything your heart desires.

Habit 6
BE A MAVERICK

'Creativity is about connecting things. When you ask creative people how they did something, they feel a little guilty because they didn't really do it, they just saw something.'
Steve Jobs

maverick *(noun)*
A person who thinks and acts in an independent way, often behaving differently from the expected or usual way.
Cambridge English Dictionary

In a world of fast-paced change and innovation, adopting a maverick mindset is becoming increasingly important in order to keep up, generate fresh ideas and deliver creative responses to new challenges.

Mavericks tend to see the world differently –

they are risk-taking, creative and out-of-the-box thinkers. They approach problems from unique angles. They question the ways that things have always been done, and this approach is one that leads to innovation. As a result, companies thrive creatively with mavericks behind the scenes. A scientific study by Elliroma Gardiner and Chris Jackson found that changes in the working world have meant that businesses have become far more reliant on the skills of mavericks in order to keep ahead in the competitive marketplace.[1]

The co-founder of Pixar Animation Studios, Ed Catmull, observed that ground-breaking movies such as *Toy Story* and *Monsters, Inc.* were only possible because a maverick spirit was encouraged in the team. In the film studio set-up, the teams invited critical feedback from each other in order to learn and improve in their work. What is certain is that we don't need people in positions of power who replicate what has come before, because that stifles progress.

I have worked around mavericks most of my life, and have found they tend to be highly creative, fun and challenging people. There is rarely a dull moment when they are around. These types are often committed to getting results. They will happily break the normal way of thinking about problems or situations in order

to achieve their goals. Mavericks can be difficult to work with sometimes – it's often their way or no way – but they do get things done, and in interesting ways. I have always felt a maverick spirit inside myself too.

When working with these types of characters, you can expect the unexpected, and this unpredictability opens doors to new ideas and opportunities, and to new ways of doing things. And this is what the future global economy needs.

So how can you become more of maverick?

How to cultivate a maverick mindset

△▽△ ▽△▽△▽△ ▽△▽

There are seven defining characteristics of a maverick archetype:

Keep pushing boundaries

Steve Jobs, the founder of Apple, was a classic maverick. He had a highly creative approach to innovation and worked intensely to find new ways of doing things. He saw solutions to problems that no one else had spotted. He didn't care too much what people thought of him or his ways of getting things done. The result was pioneering new technological devices that have revolutionised the world, and his company is now

one of the most successful and valuable in history.

Even when Apple was struggling, Jobs saw a way to improve the business model. He changed tactics on a whim, expanding the company into new areas. No longer was the company Apple Computer, Inc., it became Apple Inc., a technology business that took listening to music into the digital age. He was responsible for the invention of the iPod and iTunes – revolutionary concepts of the time. He helped to define a new category of mobile devices that are now ubiquitous, from tablets to smart watches and a whole new dimension of personal computers. Jobs had a knack of predicting what people wanted before they even knew it themselves.

In changing the business model and diversifying Apple's output, Jobs wasn't afraid to embrace change; he steered his company dynamically and flexibly. If one part of the organisation was not working, it was quickly dissolved. An ability to be flexible and to keep pushing boundaries is fundamental to the approach of a maverick. Embracing change helps us to keep pace with the outside world; mavericks know this better than the rest and do it effortlessly, without apology (Jobs was notoriously demanding to work with and quick to get angry if things were not done the way he wanted, correctly or on time).

When you work with a maverick, the goalposts tend to keep shifting, deadlines often get dismantled and things don't progress in a linear fashion. Mavericks move in a zig-zag trajectory to get from A to B, rather than a straight line – and that's the fun of this approach. If there is a plan, you can be sure that the maverick will change it and come up with new ways of executing it along the way. They keep everyone on their toes and expect people to embrace change with little notice or explanation. So, it's important for you as a maverick to remember that in order to achieve your end goals, you need to learn to bring people with you along the way.

2 Take risks

Successful maverick entrepreneurs are those who take risks without being attached to the outcome. They test out new methods, no matter how crazy they may seem to others. They are guided in their decision-making by their gut instinct and emotional signals, rather than using logic or extensive research or data. They carefully monitor the outcomes of their decisions to see what worked and what didn't, and they then make the necessary adjustments – and fast.

Richard Branson, founder of the multi-national Virgin Group, exemplifies the maverick personality.

Branson's first business venture came when he launched a student magazine aged sixteen. He set up a mail-order record business in the 1970s before opening a chain of record stores that quickly became successful. This business became Virgin Records, which then launched onto the high street as Virgin Megastores.

Having established the Virgin brand down on the ground, Branson then decided to take to the skies and in the 1980s launched Virgin Atlantic airlines. At the time his fellow board members were uncertain that the idea would work as the aviation business was notoriously competitive, but Branson was the majority shareholder and pushed through the idea against the view of his company colleagues.

Branson continues to take risks in order to innovate and is currently developing a spaceflight corporation called Virgin Galactic, designed for tourism in space. The hallmark signature of a true maverick – expand beyond the normal frontiers.

As Branson notes in his autobiography, sometimes the riskiest decision you can make is to do nothing. Similarly, Mark Zuckerberg of Facebook said that in this fast-changing world, the only strategy that is guaranteed to fail is one of not taking enough risks. When we stay within the borders of what we know, we can stagnate, and life feels dull. Taking risks, however,

and moving out of our comfort zone, helps to create new adventures, which are the fuel of creativity.

3 Be curious

The mind is naturally curious and hardwired for learning. Learning keeps us moving forward – just think how far we've come since the time when mankind made simple tools, through to the agricultural revolution, the industrial revolution and now with advancements in technology and AI. Only through learning new things can we keep pushing the boundaries of human expression.

Children are naturally curious and spend their early years exploring, imagining and learning. As adults, we can get complacent and forget to keep learning and stay curious. But the essence of creativity, and a maverick mindset, is embedded in the function of learning and remaining curious. Mavericks enjoy following their natural curiosity, trying new things or doing regular activities in a different way. When we set out to learn new skills, we open ourselves to new possibilities and ways to experience the world. This, in turn, leads to new methods and exciting innovation.

Studies show that creative thinking is about making new connections.[2] In *The Art of Scientific Investigation*, Cambridge University professor W.I.B.

Beveridge wrote that successful people usually have a broad range of interests and read widely on different subjects. Thinking and investigating ideas from a comprehensive range of subjects enhances our natural creativity and curiosity, because in doing so, we are more likely to be able to connect different concepts to make something new.

Great pioneers in industry have excelled at being curious, questioning the established approach and creating new models of thinking about the world. Steve Jobs studied calligraphy after he dropped out of Reed College. He told Stanford's 2005 graduating class in a keynote speech that when they were designing the first Macintosh computer, his calligraphy skills inspired him to design a computer that offered beautiful typography. In a similar way, don't be afraid to try out something new and unexpected. If you haven't painted before, now is a great time to try. If you have always wanted to play a musical instrument but have never got around to it, start now and see how these new talents can be brought into whatever creative projects you are working on.

Constant enquiry and curiosity keep us engaged, interested in life and young in mind.

4 Make up new rules

During their research, Elliroma Gardiner and Chris Jackson also discovered that mavericks are comfortable challenging established rules in the pursuit of their goals. Maverick types are not worried about getting things wrong and they feel comfortable in tearing up the rule book and creating something completely new. They recognise that you have to make some mistakes to be at the cutting edge of ideas and to explore new frontiers successfully.

Arkadi Kuhlmann, founder and CEO of the bank ING Direct USA, is an example of a successful rule-breaker. He made waves in the banking sector when he changed the way the system dealt with its customers. He wanted to develop a banking model to help people *save* money, rather than spend it, an opposite approach to most banking establishments of the time. It was unconventional but ultimately successful: the company was successfully acquired by Capital One for nine million dollars a few years later.

5 See the big picture, but don't ignore the detail

Typically, a maverick will approach a new situation from a 'big picture' point of view. They find it easy to view the macro perspective of a situation and tend not to get too immersed in the details.

In my experience, the most successful mavericks in business are the ones who can also bring an eye for detail. Holding a macro and micro viewpoint together in harmony allows the different perspectives to work together to create innovative frameworks for ideas that are practical and can actually work in the world. When we embrace both ends of this spectrum – getting the big picture right, while having an eye on the finer details – the magic of success starts to appear.

Leonardo da Vinci is a great example of this kind of maverick character. An inventor, painter, artist, sculptor and architect, da Vinci is widely held to be one of the most diversely talented and creative individuals in history. The scope and depth of his interests are without precedence. His mind appeared to have superhuman qualities, as described by art historian Helen Gardner.[3] He invented flying machines and devices to generate solar power. His view of the world spanned the metaphysical realm but was also based in logic: he learnt to draw the human anatomy in great detail by producing endless sketches. He was also part of a major civil engineering project in Constantinople that required him to produce a drawing of a single span 220-metre bridge. He was able to transition from the big picture to the micro details and have mastery of both.

Be determined and persevere

6 A noticeable characteristic of most mavericks is their tendency to be 100 per cent focused and determined once they have made up their mind to do something. They can also be single-minded in their approach and keep going regardless of what is happening around them.

Take Steve Jobs at Apple, Mark Zuckerberg at Facebook, Richard Branson at Virgin and Elon Musk at SpaceX: all are notorious for not giving in when the going got tough. With grit and determination, they pursued their goals, jumping over seemingly impossible hurdles, learning and modifying their tactics as they went. This can be a difficult process, and you may have to step over the naysayers to stay on the right path. The trick is to know when to keep going and when to stop or change direction.

Even when you have mastered something, determination and perseverance are still important. Jimi Hendrix had a unique gift for playing the guitar, and yet he still chose to practise as much as possible. He would take his guitar with him when he boarded a plane so that he could keep playing; he played while he was cooking and moving around his house. It's useful to remember that even those with exceptional artistic talents need to keep working on their skills.

Commitment and regular practice are the keys to being the best at your craft. This is particularly true in the world of creativity.

7 Seek clarity

Being clear about where you want to go and what you want to achieve is an important value for creative success and for a maverick mindset. Clarity of thought, speech and action combine to create a powerful channel of energy that will help you to find the resources you need to complete your project successfully.

If you ask a company management team about their strategic goals, they will know the corporate mission statement; they will have developed business plans, set financial targets and made clear goals for the year ahead, as well as the next three and five years. However, in my coaching experience, I have found that very few individuals have the same level of clarity about their own personal life. It is a strange imbalance when you consider that we are the only ones responsible for managing and designing our lives. We cannot delegate that to someone else. We have to be the ones to do this.

Therefore, be a maverick when it comes to planning what you want outside of your working

world. See the big picture, be clear about what you want from your personal life and who you want to be. Don't get caught up with working so hard that you forget to appreciate the joys of the simple sides of life: spending time with friends and family, taking regular holidays and playing a valuable part in your wider local community.

Write down your personal objectives as a mission statement or a list of specific goals. This is a useful way to get clarity on any task or activity, because the act of writing down our deepest intentions helps the mind to connect with them in a more powerful way. Add these objectives to your daily positive affirmations and you are set for success.

MY PERSONAL OBJECTIVES...

How to cultivate a maverick approach in the workplace

1. Invite people from connected or related industries to view in-house projects so that they can offer fresh perspectives, new ideas and experiences.

2. Foster a collaborative atmosphere at work. Encourage regular face-to-face discussion and collective brainstorming. Try not to rely on email or digital workspaces to exchange ideas. It's in the one-to-one exchange of ideas that new concepts and solutions can spring up most easily.

3. Create a sense of play when developing ideas and strategies. Use cue-card games to help with brainstorming, or bring in new ideas from films, music, magazines and other cultural references to help encourage expansive thinking.

4. Diversify your team. Add people of different backgrounds, experience, cultures and ages to bring unique viewpoints and ideas.

5. Encourage people to feel like change-makers and to share their ideas and enjoy having their voices heard. Good ideas often come from within the business.

6. Frequently discuss the organisation's mission, vision and values and make sure everyone knows what the mission is about.

7. Set a good example for creative practice within the company. Discourage people from being critical of others' ideas and ask that all ideas are given space and fair consideration while brainstorming and visioning.

EXERCISE: MEET YOUR INNER MAVERICK

Remembering the key attributes of a maverick mindset, make a note of how many of them you are bringing into your daily life. You should aim to cite three examples of each. If you can't then you may need to work on developing this area further.

1. **Pushing boundaries:** When did you last change something that wasn't working into something better? How have you changed tactics to reach a better result?

2. **Risk-taking:** Think of a time when you've trusted your gut. When did you last make a decision that could have gone disastrously wrong? Did it work out? If it went wrong, what did you learn?

3. **Openness and curiosity:** When did you last do something new? How open are you to new ways of working? When did you last listen to your intuition? Did it teach you something useful?

4. **Rule-breaking and making:** When have you broken the rules to reach your goals, or made your own rules for success? In what areas could you use this in the future to good effect?

5. **Macro- and micro-thinking:** Think of examples of when you've pursued the bigger picture and won. When has paying attention to the details got you where you need to be?

6. **Determination and perseverance**: What have you stuck at lately? What hurdles have you had to overcome? What did you learn through persevering?

7. **Clarity:** Are you clear about your goals and intentions? Write down your goals for the year ahead and longer. Find seven short-term goals (within a year) and seven long-term goals (beyond a year).

MY GOALS — SHORT TERM

1.

2.

3.

4.

5.

6.

7.

MY GOALS — LONG TERM

1.

2.

3.

4.

5.

6.

7.

Habit 7

FUTURE-GAZING

'We are called to be architects of the future,
not its victims.'
Buckminster Fuller

Most highly creative people I know always keep an eye
on future trends and are excited about coming up with
new ways of doing things or combining fresh ideas in
unique ways. They tend to be at the leading edge of
new technology; they know about the latest gadgets,
the best apps and what's happening in culture, music,
art, fashion and the media.

As Mark Twain said, 'There is no such thing as a
new idea. It is impossible. We simply take a lot of old
ideas and put them into a sort of mental kaleidoscope.
We give them a turn and they make new and curious
combinations.' Indeed, musicians and DJs re-mix older
styles of music to make something that sounds entirely
new. They may be influenced by other genres and then

take these ideas to create a totally fresh and different sound. In a similar vein, inventors sometimes take ideas from a range of disparate and unconnected areas and put them together to create something completely unique.

In this final chapter we look to the future of creativity, the future of work and the future of our place in the world. We will explore how increasingly important creativity will become in a landscape impacted by extraordinary developments in technology. We are going through so much change, at such a fast rate, that it is hardly possible for us to imagine what the world will be like fifty years from now. Yet we must, if we are to keep our ideas and innovations relevant and lead fulfilled and vibrant lives.

Look how far we've come

In the course of human civilisation, seventy years is a very short time, yet looking back, the world was a very different place seventy years ago: the internet had not been invented, there were no mobile phones and no personal computers in offices and homes as we see today.

It's astonishing to think that the internet, as we now know it, was only created by Tim Berners-Lee in

1989. Its impact on our experience as humans is hard to comprehend, even for those of us who have lived through the transition from before internet to now.

I mean, just imagine a world where most business was conducted by telephone, fax and physical mail, where phones were fixed to the wall by cables and if you left the house or were not close to a hardwired phone, you were not contactable. Plans had to be arranged in advance, and you stuck to them because the only way to contact someone was by calling their landline or writing a letter.

We watched videos on big VCR machines and listened to music on cassette tapes. Most children today probably wouldn't even know what a cassette or video tape is, and they would be hard-pressed to imagine life without access to a tablet, smartphone or computer of some sort. Yet all of this has happened in the last thirty years. So what will the next thirty years bring? Are we ready for the future? And where does creativity fit in to the future?

Be a futurist

△▽△ ▽△▽△▽△ ▽△▽

The rapid pace of technological development, particularly in the field of AI, is going to have a dramatic impact on numerous industries – and in the very near future. In order to stay one step ahead of the game, it's important to consider how this may affect your currency in the workplace.

In the US, for example, the landscape for lawyers is changing fast. With software such as IBM Watson, ordinary people can access sound legal advice from a computer within seconds, with 90 per cent accuracy, compared to 70 per cent accuracy from humans.[1] Its likely, then, that there will be less need for lawyers in the future, with probably only specialist legal advisors still being required.

Software has also been developed to help people working in the medical industry diagnose cancer, with an accuracy that is four times more precise than human diagnosis.[2] Technology companies are developing medical devices that work with your phone to take a retina scan, analyse a blood sample and a breath sample. The software can then be used to analyse a range of biological markers that identify nearly any disease. All this will mean that medical care becomes more accessible to individuals away from the

healthcare system, doctors and hospitals.

There has also been much speculation about the disruption to the car industry caused by the advent of self-driving cars. In the future, you will be able to call for a car on your smartphone and it will show up to drive you to your destination. It's likely that the next generation of children won't need to get a driving licence or even own a car.[3] This will have an impact on town planning, as we will need fewer parking spaces.

It is predicted that a million lives will likely be saved from the reduction of cars on the road. There is currently one accident for every 60,000 miles (100,000 kilometres), and with autonomous driving that figure is estimated to drop to one in 6 million miles (10 million kilometres). Car insurance business models will crumble as a result.

It is estimated that 75 per cent of current jobs will disappear in the next twenty years.[4] There will, of course, be new jobs and new industries, but we can't know if there will be enough jobs for all. So how can we futureproof ourselves as we enter this technological revolution?

The future of creativity

The good news is that in harnessing the habits explored in this book, you are already one step ahead. Computers lack imagination, personality and an emotional framework of consciousness – something that still gives us humans an edge.

The more the world as we know it changes through technological advances, the more important creativity will become to ensure that we lead rewarding and meaningful lives. With your maverick mindset, you will be better able to embrace change and spot new opportunities and potential gaps in the market. AI is going to take hold in a big way, so rather than fear it, let's use it to enhance our natural creative abilities.

When I spoke to Clay Douglas, an expert in artificial intelligence, he explained that one of the things AI allows us to do is generate a large number of ideas and test each of them very quickly, without the same level of error as humans. For example, if there is a range of options to consider on any project, AI can test each one and quickly compute answers into reliable statistics. This fast and effective decision-making process enables us to build future models and create new innovations more simply and elegantly than before.

Take a game like chess, or Go, where AI found its

dominance around twenty years ago. These are highly creative games, requiring great skill and a tactical process. Players need to demonstrate highly creative behaviour to play – something it was believed only humans could do. As it turns out, the best players are the ones who use AI and their own creative strategies. The AI proposes and tests options that the player then chooses from, enhancing their own natural ability and creativity.

As Clay Douglas explained to me, humans are not as good at knowledge as machines – machines are faster and more technically competent. In the past, office work was considered a more desirable option than factory work because it was less repetitive. Both administrative and manual tasks will soon be done by AI – and far more efficiently and accurately than humans ever did them. That is why it is important that education systems make the shift from a knowledge-based model to a creativity-based one. We need to ensure that our children have useful skills to offer a world that we can't even imagine yet.

The future can be bright – but only if we give future generations the tools and wisdom they need to unleash their full potential. We are facing a time of dramatic change on our planet, and, with this change, we notice that there is a paradigm shift towards

new possibilities, wider viewpoints and, all in all, a field of great potential for people today. We are all responsible for taking life to new levels by making good daily choices to empower ourselves and each other, helping us to stay happy and fulfilled by exercising our unique creative talents and flair. This book has taken you through those levels, and shown you how to uncover what's beneath their surface.

It seems that now we need to pay more attention to the need for innovation and creation, and make changes that will allow us to not only survive, but to prosper and flourish. As we make adjustments and meet our own creative self more profoundly than we have before, we have the joy of understanding what drives us from the inside out. From this place, we get closer to enjoying the art of learning and developing our own talents, from a place of greater understanding.

I hope your exploration of the art of creativity takes you on a wonderful journey in which you find joy, and that this joy can spread through the world. Creativity has the power to heal not only the individual, but the world as we know it; and we are only at the beginning.

Go out, get creative and enjoy the ride of unleashing your most powerful self. We all have a creative ocean inside ourselves – now is the time to let it flow.

'There is an ocean of creativity
within every human being.'

David Lynch

There is an ocean of creativity
within every human being.

David Lynch

REFERENCES

Introduction

1. Carrie Battan, '"The artist's way" in an age of self-promotion', *The New Yorker* (May 2016). See https://www.newyorker.com/culture/cultural-comment/the-artists-way-in-an-age-of-self-promotion

2. Poll by *Time* magazine, 'Assessing the Creative Spark' (May, 2013). See Assessing the Creative Spark | TIME.com

3. 2018 Global Human Capital trends report from Deloitte Insights. See https://www2.deloitte.com/content/dam/Deloitte/at/Documents/human-capital/at-2018-deloitte-human-capital-trends.pdf

Habit 1: Fears and Blocks and How to Overcome Them

1. See https://www.sciencedaily.comreleases/2010/06/100603172219.htm

Habit 2: Journaling

1. Statistics from the 2005 National Science Foundation report on the study of thoughts. See http://www.sentientdevelopments.com/2007/03/managing-your-50000-daily-thoughts.html

2. Judy Willis, *Brain-friendly Strategies for the Inclusion*

Classroom: Insights from a Neurologist and Classroom Teacher (ASCD, 2007)

3. Jennifer Lodi-Smith, Aaron C. Geise, Brent W. Roberts, Richard W. Robins, 'Narrating personality change', *Journal of Personality and Social Psychology*, vol.96 (2009), pp.679-689.

4. Reza Falahati, 'The relationship between students' IQ and their ability to use transitional words and expressions in writing', *Working papers of the Linguistics Circle of the University of Victoria*, vol.17 (2003). See https://journals.uvic.ca/index.php/WPLC/article/view/5160

5. Melanie Sperling, 'Revisiting the writing-speaking connection', *Review of Educational Research*, vol.66 (March 1996). See https://journals.sagepub.com/doi/abs/10.3102/00346543066001053

Habit 3: Meditation and Breathing

1. See https://www.thegoodbody.com/meditation-statistics/
2. See https://eocinstitute.org/meditation/whole_brain_synchronization/
3. National Library of Medicine and National Institute of Health USA. See https://www.ncbi.nlm.nih.gov/pmc/articles/PMC3057175/
4. See the David Lynch Foundation website. The scientific sources for these effects are listed on the website under the section on research: https://www.davidlynchfoundation.org/research.html

Habit 4: Boosting Your Brainwave States and Mind-mapping

1. Christopher Bergland, 'Small Acts of Generosity and the Neuroscience of Gratitude', *Psychology*

Today (October 2015). See https://www.psychol-
ogytoday.com/us/blog/the-athletes-way/201510/
small-acts-generosity-and-the-neuroscience-gratitude

2. Dr Masaru Emoto, 'Effect of Distant Intention on Water
 Crystal Formation', *Journal of Scientific Exploration*, vol.22
 (December 2008). See https://www.researchgate.net/
 publication/255669110_Effects_of_Distant_Intention_on_
 Water_Crystal_Formation_A_Triple-Blind_Replication and
 his *New York Times* bestselling book, *The Hidden Messages in
 Water* (Atria Books, 2011).

3. Simone Ritter and Sam Ferguson, 'Happy creativity:
 Listening to happy music facilitates divergent thinking',
 Journal of Cognitive Enhancement, vol.1 (September 2017). See
 https://journals.plos.org/plosone/article?id=10.1371/journal.
 pone.0182210. The study was conducted and supported by the
 Netherlands Organisation for Scientific Research (NWO).

4. See https://chopra.com/articles/
 rewire-your-brain-for-happiness.

Habit 6: Be a Maverick

1. Elliroma Gardiner and Chris Jackson, 'Personality and
 learning processes underlying maverickism', *Journal of
 Managerial Psychology*, vol.30, no.6, pp. 726–740 (August 2015).
 See https://www.emerald.com/insight/content/doi/10.1108/
 JMP-07-2012-0230/full/html

2. Jan Gläscher, 'Brain system behind general intelligence
 discovered', California Institute of Technology
 (February 2010). See https://www.sciencedaily.com/
 releases/2010/02/100222161843.htm

3. Helen Gardner (10th ed.), *Art Through the Ages*
 (Wadsworth, 1995).

Habit 7: Future-gazing

1. Mohan Thite (ed.), *e-HRM Digital Approaches, Directions & Applications* (Routledge, 2018). See https://www.routledge.com/e-HRM-Digital-Approaches-Directions--Applications-1st-Edition/Thite/p/book/9781138043978; James Ausman, 'A View of the Future from Mercedes Benz', *Surgical Neurology International*, vol.8:224 (September 2017). See https://www.ncbi.nlm.nih.gov/pmc/articles/PMC5609448/

2. See https://www.linkedin.com/pulse/must-read-article-how-our-lives-change-dramatically-20-delahunty https://www.psychologytoday.com/us/blog/the-athletes-way/201510/small-acts-generosity-and-the-neuroscience-gratitude and https://psycnet.apa.org/record/2009-02415-013

3. See https://dzone.com/articles/how-automotive-ai-is-going-to-disrupt-almost-every.

4. James Manyika *et al.*, McKinsey Global Institute report, November 2017, 'Jobs lost, jobs gained: What the future of work will mean for jobs, skills and wages'. See https://www.mckinsey.com/featured-insights/future-of-work/jobs-lost-jobs-gained-what-the-future-of-work-will-mean-for-jobs-skills-and-wages.

FURTHER READING

Ban Breathnach, Sarah, *Simple Abundance: A Daybook of Comfort & Joy* (Bantam, 1997).

Brand, Russell, *Recovery: Freedom from Our Addictions* (Bluebird, 2018).

Cameron, Julia, *The Artist's Way: A Course in Discovering and Recovering Your Creative Self* (Macmillan, 2016).

Gawain, Shakti, *Creative Visualization: Use the Power of Your Imagination to Create What You Want in Your Life* (New World Library, 2002).

Gilbert, Elizabeth, *Big Magic: Creative Living Beyond Fear* (Riverhead Books, 2015).

Goddard, Neville, *Feeling Is the Secret*, 1944 (Merchant books, 2013).

Goddard, Neville, *Awakened Imagination*, 1946 (Merchant Books, 2012).

Hardy, Jayne, *The Self-care Project* (Orion, 2017).

Hay, Louise, *The Power Is Within You* (Hay House, 1991).

Hicks, Esther and Jerry, *Ask and It Is Given: Learning to Manifest Your Desires* (Hay House, 2010).

Hill, Napoleon, *You Can Work Your Own Miracles* (Random House, 1971).

Kondo, Marie, *The Life-changing Magic of Tidying: A Simple,*

Effective Way to Banish Clutter Forever, (Vermilion, 2014).

Lynch, David, *Catching the Big Fish: Meditation, Consciousness, and Creativity* (Penguin Random House, 2016).

Owen, Alysoun and Phillips Harrington, Eden (eds), *Writers' and Artists' Yearbook 2020* (Bloomsbury, 2020).

Pearl, Susie, *Instructions for Happiness and Success* (Quadrille, 2012).

Wattles, Wallace D., *The Science of Success* (Sterling Publishing Co., 2007).

ACKNOWLEDGEMENTS

I would like to give thanks to all who have helped me on my journey with this book and who have supported me in so many ways.

Gratitude to my loving family, my rock-solid Ibiza community and my literary agent, Lorella. Special mention to my amazing son, Will, who is my lockdown hero and has supported me in so many ways during the writing of this book. Thanks to my publisher and editor Anna Valentine at Orion Spring, who provided unwavering support, good humour and guidance along the way. Anna saw the vision and potential of this book and performed magic on the manuscript as it evolved.

Thanks to David Lynch for his generous support of this work. Appreciation and thanks to all those who have come along to meet me at workshops and talks. I hope this book will find its way into the hands of those whose lives will benefit from the creative journey contained here.

NOTES AND INSPIRATION . . .

ABOUT THE AUTHOR

Susie Pearl is an author and podcaster. She is the author of *Instructions for Happiness and Success* and writer of *Farmacy Kitchen*, a plant-based conscious-eating cookbook. She is the founder and CEO of international PR agencies in London and Ibiza, has worked for Sony and MTV and represented A-list celebrities, brands and music artists around the world. She has been responsible for running the media and press for the MTV Europe Music Awards for many years, and she ran a personal development training company for Paul McKenna and Dr Richard Bandler, co-creator of NLP.

Susie is a lover of words, books and ancient wisdom. She grew up in the UK countryside with a loving family and spends her time living between Ibiza and the UK. Susie has a son, Will, who has a special place in her life and makes her feel very proud of being a mum. She is a cancer survivor, meditates regularly and works closely with the David Lynch Foundation in the UK and US to help get Transcendental Meditation® out to the world where it is needed most.

Please sign up to my newsletter to keep up to date
with news and related stories:

www.susiepearl.com

You can also connect with me here:

- Susiepearlx
- susie_pearl
- @susiepearlwriter
- info@susiepearl.com

If you enjoyed reading this book please consider
leaving a review on a site of your choice. Reader reviews
support authors and help others discover new books.